IMAGES
of America

ALBANY

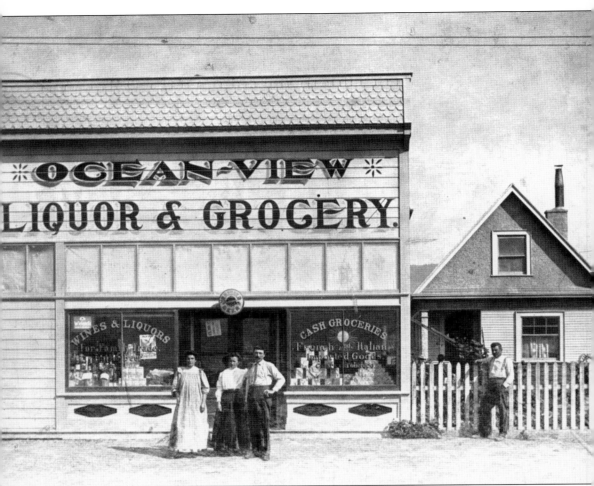

Albany was not always known by its current name. When the city first incorporated in 1908, it was called Ocean View. Here one of the town's first businesses, an Italian grocery located in the 900 block of San Pablo Avenue, displays the original city name. Pictured from left to right are Tersilla Conca, a neighbor; Rosa and Peter Villa, both of whom worked in the grocery and became the owners; and Charles Colson, who may have originally owned or operated the store. (Courtesy Joe Villa, AHS.)

ON THE COVER: Kathleen Watkinson stands in the garden at her house near the east side of Albany Hill, *c.* 1923. (Courtesy Mary Wallmann, ALHC.)

IMAGES
of America

ALBANY

Karen Sorensen and
the Albany Historical Society

ARCADIA
PUBLISHING

Published by Arcadia Publishing
Charleston SC, Chicago IL, Portsmouth NH, San Francisco CA

Printed in the United States of America

Library of Congress Catalog Card Number: 2007923077

For all general information contact Arcadia Publishing at:
Telephone 843-853-2070
Fax 843-853-0044
E-mail sales@arcadiapublishing.com
For customer service and orders:
Toll-Free 1-888-313-2665

Visit us on the Internet at www.arcadiapublishing.com

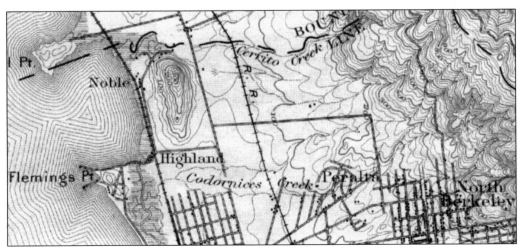

This 1895 U.S. Geological Survey topographic map shows the sparse development of the Albany area at the time. The long slough that ran south of Fleming's Point (now the site of the Golden Gate Fields racetrack) is depicted, as are the buildings of the powder and chemical companies near Fleming's Point and Albany Hill. The Southern Pacific Railroad tracks appear to the left, and the California and Nevada Railroad tracks on the right (the latter is where the BART [Bay Area Rapid Transit] tracks would eventually run in Albany). (Courtesy University of California, Berkeley.)

CONTENTS

ACKNOWLEDGMENTS

Numerous people provided assistance to make this book possible. First and foremost, I extend my sincere thanks to the board of directors of the Albany Historical Society: Ruth Ganong, Joan Larson, Peggy Mc Quaid, Jewel Okawachi, Jack Rosano, and Marsha Skinner. The board spent many hours supporting this effort in ways too numerous to list here. Images that appear in the book that are part of the society's collection and preservation efforts are denoted with "AHS," which usually appears after a specific contributor's name.

I also owe a debt of gratitude to the Albany Library, especially reference librarian Richard Russo and manager Ronnie Davis, who both provided generous access to the library's historical collection and went out of their way to help. Many of the images used in this book are from the library's collection and are identified with "ALHC."

For years, the Albany Fire Department kept detailed scrapbooks and collected photographs, as did the late Catherine Webb (many of these materials are now at the library). Both Webb and the police and fire departments' Civil Service Club published previous Albany history books. I am grateful to these historians for their efforts. The city is also fortunate to have many long-term residents, friends, businesses, and organizations who agreed to share cherished memories, scrapbooks, and private collections; it was these combined efforts that produced the many "new" historic images of Albany included in this book.

Several people provided helpful advice and reviews, including the following: Tom Panas, president of the El Cerrito Historical Society; Paul Grunland, a longtime member of the Berkeley Historical Society; Beverly Ortiz, a naturalist with the East Bay Regional Park District; Dr. Randall Milliken, an ethnohistorian; Susan Schwartz, president of Friends of Five Creeks; and Timothy Lundgren, a retired Albany fire captain.

Finally, on a personal note, I send a special thank you to all my Albany friends and neighbors and especially to my family, who provided much-appreciated support during the preparation of this publication.

—Karen Sorensen

INTRODUCTION

It was a spring day in 1908 when the residents—mainly women—of what would soon become Albany, California, set out to solve an odoriferous problem. Armed with shotguns and a revolver, the group gathered just west of the area now known as San Pablo Avenue and Buchanan Street as garbage wagons from the nearby city of Berkeley approached. While a committee had recently been formed to look into the problem of Berkeley dumping trash in the area, the issue had yet to be resolved, and the residents felt the time had come for action. They stepped out in front of the wagons and demanded they turn around.

Undoubtedly alarmed by this unexpected greeting, the drivers did as they were asked. Still, a permanent, legal solution was needed—and eventually found through the incorporation of the City of Ocean View. The new city officials, who gathered for their first meetings in a refurbished barn near the corner of Brighton and San Pablo Avenues, quickly enacted an ordinance against outside garbage dumping. However, the name of Ocean View would not last long. Confusion with other cities of the same name—mail was often mistakenly sent to another Ocean View south of San Francisco—prompted a change. One name that was considered was Cerrito, after what was then known as Cerrito (Albany) Hill (the neighboring city of El Cerrito had not yet been formed). However, in 1909, Albany was chosen in honor of the city's first mayor, Frank Roberts, who hailed from Albany, New York.

This is the story of how Albany, California, was formed. But long before the beginnings of a town, the land directly across the bay from the future Golden Gate was open grassland, punctuated only by the oaks on Albany Hill and the spring wildflowers that bloomed profusely. Four primary creeks curled their way from the eastern hills toward the bay, and a large salt marsh and slough existed near the waterfront just east and south of a prominent point (the site of today's Golden Gate Fields racetrack). A sandy beach ran along the water's edge west of the marsh. Another marsh was located near the mouth of the northernmost creek, known today as Cerrito Creek, and it was near here that a group of Huchiun Indians had a settlement.

The Huchiuns, who inhabited several villages along the eastern shore of the bay, were part of the larger Ohlone or Costanoan linguistic group or cultural nationality. They managed and used an abundance of local resources—seeds, acorns, salmon, shellfish, elk, and more—for food and materials. Today the only visible evidence of their presence near Albany Hill are shell fragments (possibly part of a shell mound found in the area) and mortar rocks where members of the tribe likely pounded seeds, acorns, and other materials.

Like other Indians of the region, the Huchiuns were displaced and succumbed to disease after the arrival of the Spanish in the 18th century. In 1820, Luis Maria Peralta, a member of the famous Anza party that first colonized Alta California in 1775–1776, received an approximate 44,800-acre land grant from the Spanish government. Called Rancho San Antonio, the area stretched from San Leandro Creek in the south to Cerrito Creek in the north and later became one of the most valuable grants made in California. It included the present-day cities of Albany, Berkeley, Oakland, Emeryville, Piedmont, Alameda, and part of San Leandro. Luis Peralta later

divided the land among his four sons, giving the northern portion including present-day Albany and Berkeley to Jose Domingo Peralta. But like the Indians before them, the Peraltas were not destined to remain in charge of their land. The Gold Rush brought an influx of new settlers, and after the Mexican war, the Peraltas began to lose control over their property.

Domingo Peralta did make some successful sales of land, one of which was to J. J. Fleming, who bought a section of waterfront property in the early 1850s and raised livestock there. This subsequently became known as Fleming's Point. From the late 1870s to 1905, the Albany Hill (at the time known as Cerrito Hill) and Fleming's Point areas were the sites of explosives manufacturing plants. The plants, which supplied California gold-mining operations, aggravated East Bay residents with several serious explosions. It was during this time that the eucalyptus trees along the top of Albany Hill were first planted in hopes they would help shelter residents from the blasts.

One of the more infamous early residents of the area was actor Maurice B. Curtis, who built the Peralta Park Hotel, a massive, four-story, many-turreted structure that opened in 1891. Curtis was known for his popular play *Sam'l O'Posen*. Today's Posen Avenue in Albany is named for this stage production. Curtis envisioned the hotel as a lavish retreat for his theater friends, but his plans were thwarted when he was accused of killing a man in San Francisco and became embroiled in a lengthy trial. The hotel was then used for two different schools before being purchased in 1903 by the Christian brothers, who moved St. Joseph's Academy into the building. Eventually, the site became St. Mary's College High School.

After the 1906 earthquake, many San Franciscans moved to the East Bay area. At this time, John Spring, a prominent East Bay developer, established the large Regents Park housing tract in what would become Albany. The city soon began to expand. Before the 1920s, a second school was needed, and during the late 1920s and 1930s, many new homes were constructed by well-known builder Charles MacGregor.

During the late 1920s, Albany nearly became part of Berkeley. Albany did not yet have a high school, and teenage students had to be sent to other cities for schooling. A substantial number of residents, known as the Albany Taxpayers' League, campaigned to have Berkeley annex Albany, thereby sending Albany students automatically to Berkeley High School. While Berkeley officials appeared favorable to the idea, a large number of Albany residents, city officials, and merchants were not; their desire was for Albany to build its own high school. Officials held many meetings filled with heated discussion, and the issue was put to a vote in three different elections occurring over a few years. Each time, annexation with Berkeley was voted down, sometimes by a slim margin—yet Albany's independence prevailed. By the mid-1930s, Albany began building its own high school, using both local tax revenue and federal funds.

Like other East Bay cities, Albany's population expanded greatly during World War II. Codornices Village was established both in Berkeley and on an adjacent portion of Albany known as the Gill Tract (by this time owned by the University of California). Here housing was quickly built for Richmond shipyard workers and local servicemen. By 1956, the university had converted its portion of the village to student family housing—today's University Village. Albany's population remained relatively stable from this point—having grown from a few hundred people to today's approximate 17,000—but over the years, the city has grown and changed in other ways, evolving with the times. One constant, however, is the small-town, family-friendly atmosphere—a hallmark of Albany that continues to this day.

One

BEFORE 1908

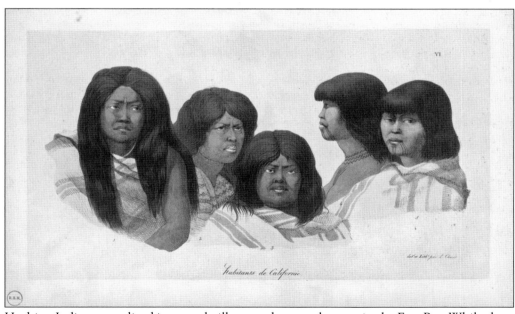

Huchiun Indians once lived in several villages and seasonal camps in the East Bay. While there are no images that specifically depict the settlement near Albany Hill, this lithograph shows Indians from various Bay Area tribes, including a Huchiun (second from left). The lithograph is based on sketches by L. Choris, a Russian artist who accompanied the Otto von Kotzebue Expedition visiting the San Francisco area in 1816. (Courtesy Bancroft Library, University of California, Berkeley.)

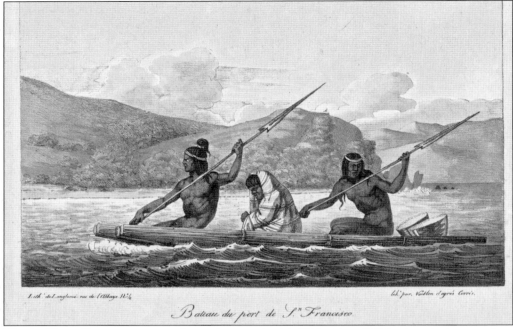

This L. Choris illustration—one of several portraying his 1816 visit to California—depicts members of a Bay Area tribe traveling across San Francisco Bay in a reed canoe. Huchiun Indians that lived near Cerrito Creek had ready access to tule reeds, as well as abundant fish and shellfish from the bay and nearby marshes. (Courtesy Bancroft Library, University of California, Berkeley.)

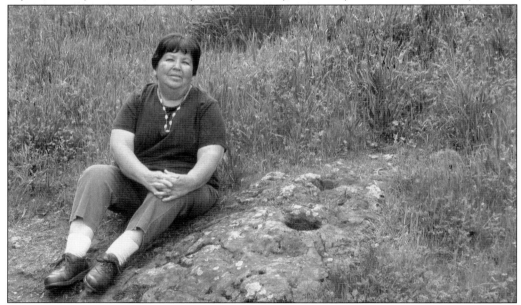

Ruth Orta is among the Bay Area Indians of today who have the closest link to the Huchiun tribe. Part of her ancestry is Jalquin and Saclan, once neighboring tribes of the Huchiuns. She appears at Albany's Creekside Park, next to the mortar rocks where Huchiuns likely pounded seeds and acorns. (Courtesy Karen Sorensen, AHS.)

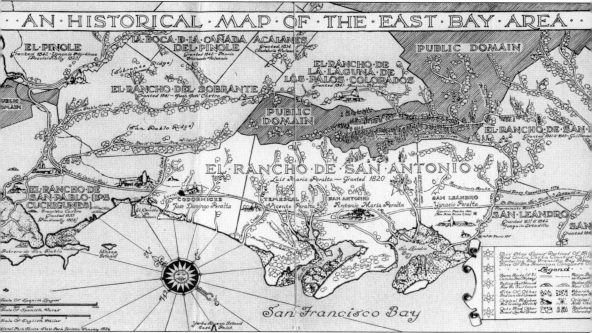

This 1936 map illustrates the Mexican and Spanish land grants that existed in the East Bay about 1846. Rancho San Antonio, granted to Luis Maria Peralta in 1820, appears at the center, along with the approximate boundaries of the four sections he later gave to his sons—Ygnacio, Antonio, Vincente, and Jose Domingo Peralta. Domingo Peralta's lands included present-day Berkeley and Albany. His adobe appears just south of Codornices Creek. (Courtesy San Leandro Library and the National Park Service.)

By 1861, when this photograph was taken, new settlers and squatters were challenging the Peraltas' ownership of Rancho San Antonio, but wide open grasslands still dominated much of the landscape. In this westward view, with Fleming's Point (the current site of the Golden Gate Fields racetrack) to the left and El Cerrito de San Antonio (today's Albany Hill) to the right, just two to three buildings are visible. This scene was captured by 19th-century photographer Carleton Watkins and submitted as evidence in a legal case involving Jose Domingo Peralta, his brother Vincente Peralta, and the federal government. (Courtesy Louis Stein, ALHC.)

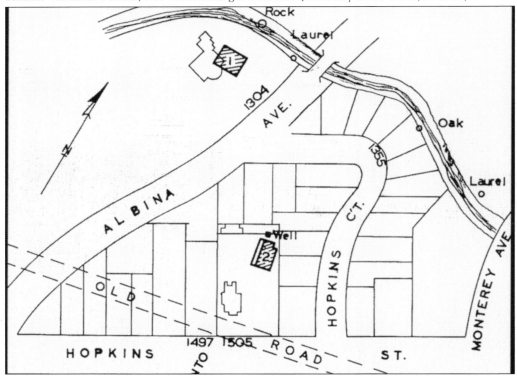

The two locations of Jose Domingo Peralta's homes are shown on this map featuring present-day streets near the Albany-Berkeley border. No. 1, near the south bank of Codornices Creek and today's Albina Avenue, is the site of the original small adobe, a one-story building with a tile roof and dirt floors constructed in 1841. No. 2 is Jose Domingo's second home, a two-story frame house built in 1851–1852 near the present-day intersection of Hopkins and Sacramento Streets in Berkeley. (Courtesy California Historical Society.)

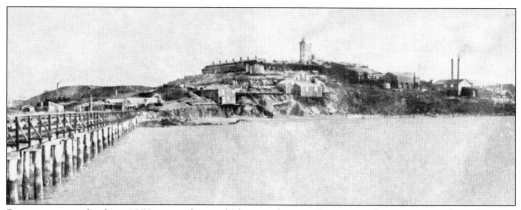

Beginning in the late 1870s, powder and chemical manufacturing plants operated in the area of Fleming's Point. The Judson and Shepard Chemical Works, shown here from a viewpoint in the bay, was located near the current site of the Golden Gate Fields racetrack. (Courtesy Albany Fire Department, ALHC.)

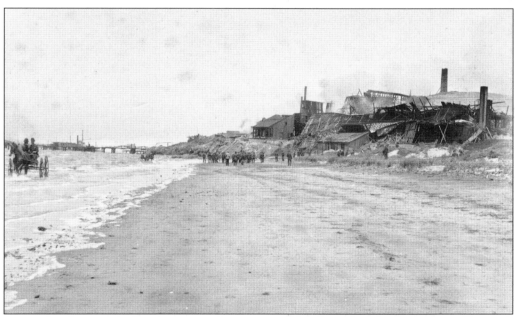

A crowd gathers on the beach to view the remains of the Giant Powder Company at Fleming's Point after a deadly 1883 explosion, one of several that occurred here and near Albany Hill over a 25-year period. This blast killed the plant's assistant superintendent and over 30 Chinese workers and leveled much of the nearby Judson and Shepard Chemical Works. The Giant Powder Company had relocated from a sand dune area near San Francisco because of protests over similar explosions. (Courtesy Berkeley Public Library.)

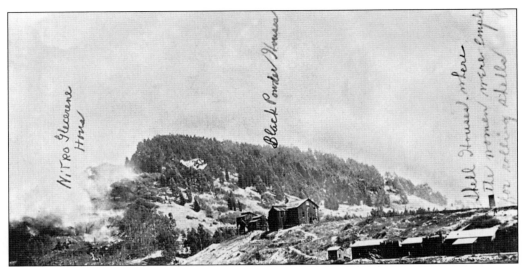

Violent explosions and a resulting fire occurred at the Judson Powder Company on the northwestern slope of Albany Hill in August 1905. The explosions, which killed the plant's foreman and damaged nearby buildings, were the last in the Albany area. Vehement protests from East Bay residents caused the company to close the plant. Notes written on the photograph identify the Nitroglycerine House (left), the Black Powder Houses (center), and the "Shell Houses where the women were employed" (right). (Courtesy Neil Havlik, ALHC.)

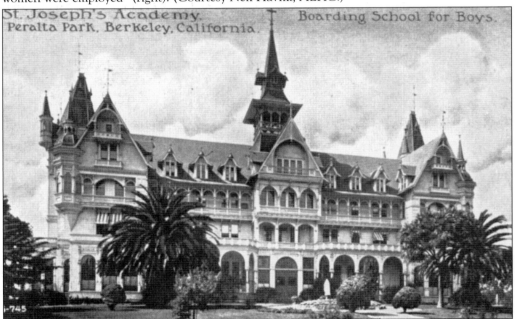

The Peralta Park Hotel, a large, ornate four-story structure, was a surprising sight to 19th-century visitors to the Albany area, which was then mostly open grassland. The hotel was built in the late 1880s by actor Maurice B. Curtis at the present-day location of St. Mary's College High School. In 1903, the Christian brothers moved St. Joseph's Academy—pictured in this early-1900s postcard—from Oakland to the hotel and dubbed the building "The Palace." (Courtesy De La Salle Institute.)

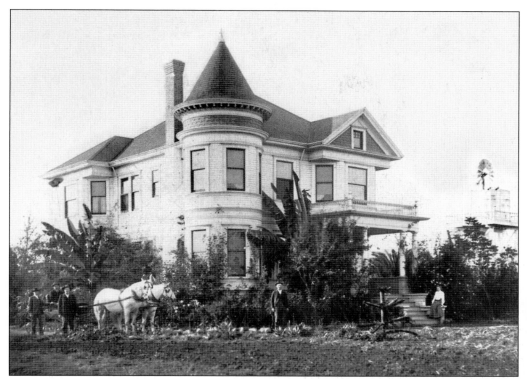

In 1890, Edward Gill, a world-renowned horticulturist, bought 104 acres and established the Gill Nursery in what would later become the southwest area of Albany. Gill was especially well-known for the antique roses he grew at the nursery until his death in 1909. In the above c. 1900 photograph of the family's large Victorian home, Edward Gill appears to the left of the horses, John Gill at the center, and Isabel Gill on the steps. Below, a haying crew works on the nursery property. (Both courtesy Elizabeth Harrington and Mary Bell Webb, ALHC.)

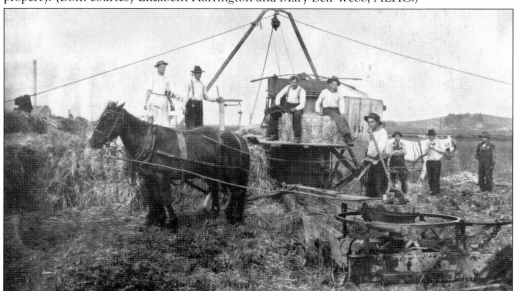

The Machados moved from Oakland to the Albany area in 1906 and bought this lot on Garfield Avenue "for $100 in gold coins," according to the family story. Originally from Portugal, six generations of the family have now lived in Albany on this street. Shown here from left to right are (standing) Amelita Marshall (Machado); (seated) Miriam Machado, an Oakland shoemaker; Frank Marshall (Machado); Julia Machado; Rose Marshall (Barbagelata); Manuel Marshall (Machado); and baby John Marshall (Machado). According to family members, Manuel changed his last name to Marshall when he discovered there were too many Machados at the Emeryville factory where he worked. (Courtesy Rose Barbagelata, ALHC.)

Ben Hamilton, pictured on his route in 1906, was the first Rural Free Delivery mail carrier for the area. (Courtesy Albany Fire Department, ALHC.)

Two

1908–1919

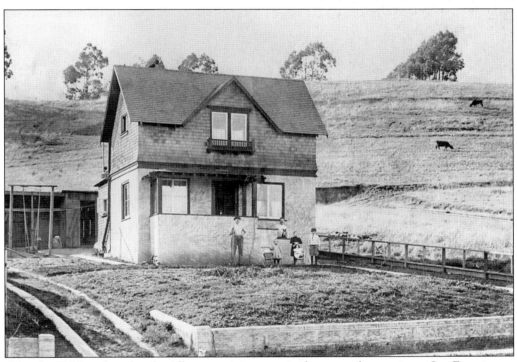

After the 1906 earthquake, the Albany area's inexpensive lots proved attractive to San Franciscans fleeing the city, as well as to others arriving from elsewhere; thus, new homes began to appear around San Pablo Avenue. This building, known as the Williams House, was located near Jackson Street and Washington Avenue. It was the "home of Mildred Hein's uncle" at the time of the 1909 photograph and was one of the first homes built near the eastern slope of Albany Hill. (Courtesy Dorothy Larimer Boyd, ALHC.)

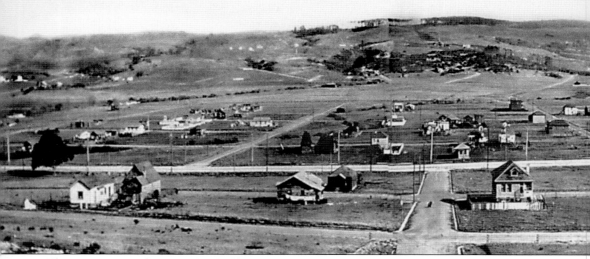

This panoramic photograph of Albany, taken about 1911 from today's Hillside Avenue and Jackson Street, shows that houses, while still sparse, are beginning to punctuate the landscape. The view stretches from Brighton Avenue at the far left to Solano Avenue (then Main Street) at the right. In the foreground are Adams Street, Madison Street, and San Pablo Avenue running

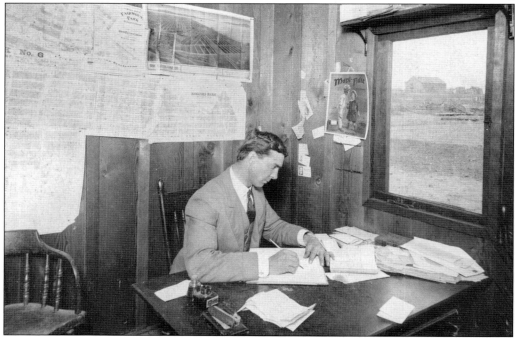

C. M. Hinton, the first city recorder for Albany (then known as Ocean View), is shown in a small office about 1908. On the wall behind him is a map of Regents Park, the large development of John Spring, which encompassed much of Albany. Spring, a prominent East Bay developer, purchased the land around 1906, the year of the San Francisco earthquake. At this time, lots near San Pablo Avenue sold for just a few hundred dollars and required only a small down payment. (Courtesy Albany Fire Department, ALHC.)

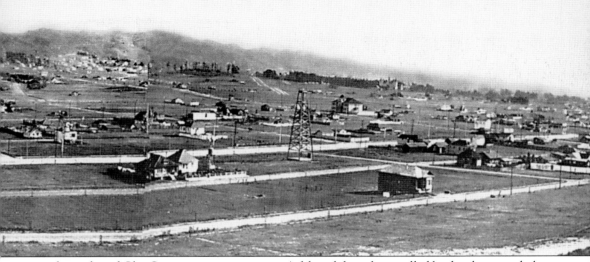

north-south and Clay Street running east-west. A fake oil derrick, installed by developers to help fuel property sales, is visible near the corner of Washington and San Pablo. Behind it on Main Street is the Albany (later Cornell) School. (Courtesy Gerald Browne, ALHC.)

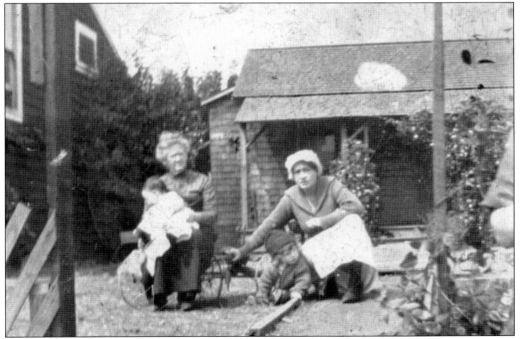

Around 1912, Sarah Donegan Stanley Simpson (left) poses with her grandchild and neighbors in front of her home at 906 Adams Street. Five generations of the family have now lived at the house, including Sarah Simpson herself, Sarah Stanley Rhodes Crummey, Stanley Thomas Anthony Rhodes, Sandra Rhodes-Dreyer (the current resident), and James Anthony Rhodes-Dreyer, who now lives elsewhere in Albany with his wife, Gabrielle Rhodes-Dreyer. (Courtesy Sandra Rhodes-Dreyer.)

Miller's Barn was the first school in Ocean View. The building was a refurbished barn owned by Chris Miller, one of three school trustees of the new Ocean View School District. Located at the corner of San Pablo and Brighton Avenues, the barn was also the site of the city's first council meetings. Ocean View's first students are seen below on the steps of the barn in 1908. B. A. Collier was appointed teacher at a salary of $70 per month. (Above courtesy Louis Stein, ALHC; below courtesy J. Karst, ALHC.)

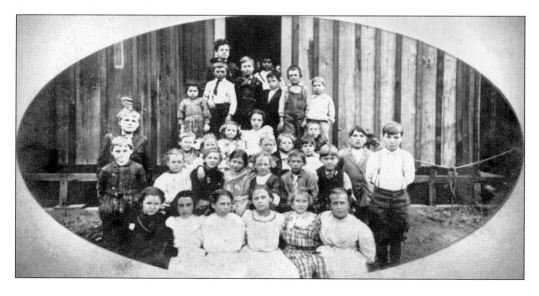

Confusion with other towns called Ocean View prompted the city to change its name in 1909, just one year after incorporation. Albany was chosen in honor of the first mayor, Frank Roberts, who came from Albany, New York. Here Roberts stands on a wooden sidewalk in front of his Albany real estate and insurance business on San Pablo Avenue. He lived first on Neilson Street and later in the 1100 block of Curtis Street. (Courtesy Albany Fire Department, ALHC.)

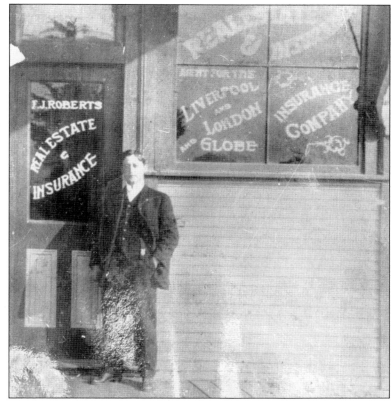

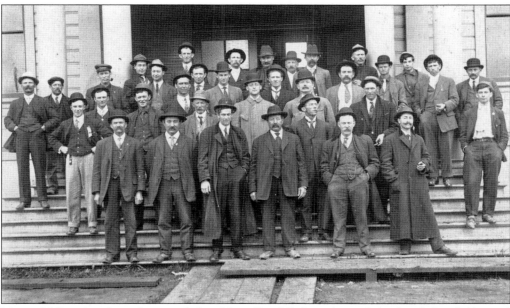

Many of Albany's early residents, including Mayor Frank Roberts (second row, fourth from left), stand on the steps of Albany School in this photograph of voters on election day around 1910. Women, clearly absent, had not yet been given the right to vote. (Courtesy Rose Barbagelata, ALHC.)

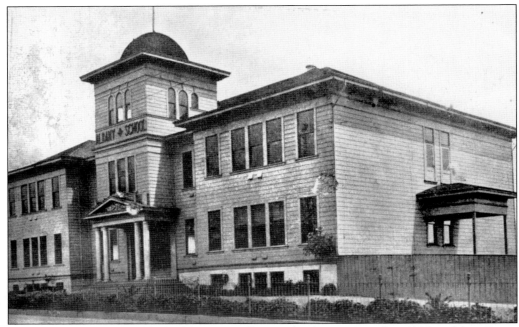

The city's first official public building was Albany School, constructed in 1908 on Main Street (Solano Avenue) between Cornell and Talbot Avenues near the site of the present-day Cornell School. The fence in front of the school, shown here about 1913, was erected to protect children from the new electric trains running along Main Street. (Courtesy Richard McSheehy, ALHC.)

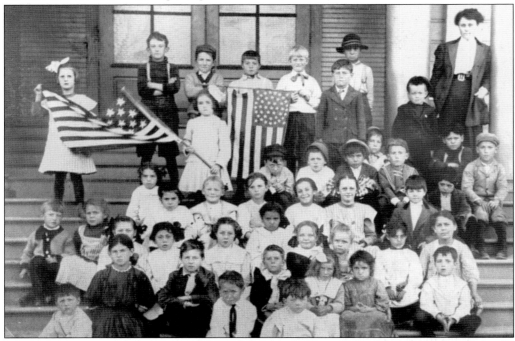

Schoolchildren pose on the steps of Albany School with their teacher, Bessie Patton, in the early 1900s. (Courtesy ALHC.)

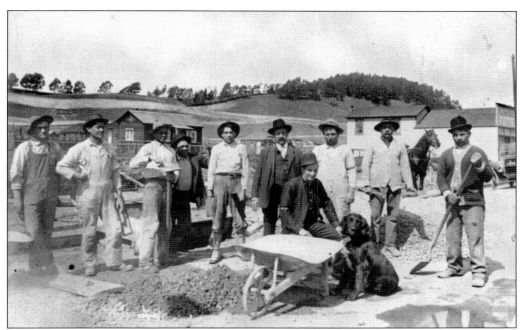

Albany's first marshal, Chris Miller (sixth from left), is pictured above with workers from the Spring Construction Company in 1910. The crew is installing sidewalks along the west side of San Pablo Avenue in the 800 block. A barren Albany Hill appears in the background. The Latronico Shoe Store is barely visible at right. From left to right, the men are Tony Rampone, Tom Gavigan, ? Chavez, unidentified, Frank Velasco, Miller, unidentified, Joe Velasco, unidentified, and ? Latronico. Below, the Spring Construction Company works on another portion of San Pablo Avenue about 1910. Horse-drawn wagons and a streetcar can be seen on the east side of the street. (Above courtesy Anne Latronico Spencer, ALHC; below courtesy ALHC.)

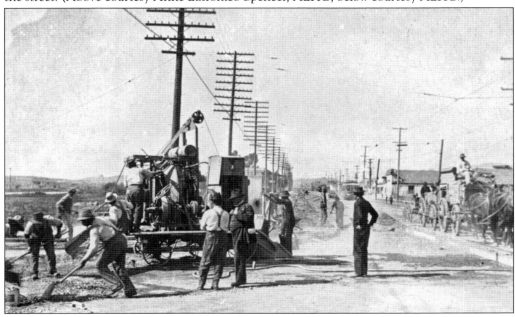

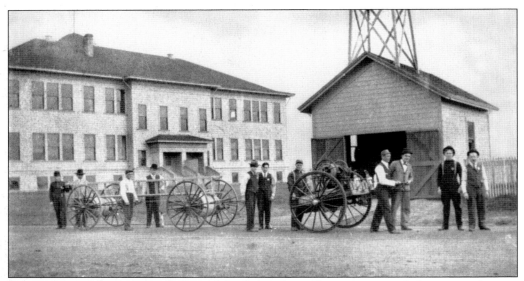

After Albany School was built, one of the first orders of business was to help protect the new city from fire. A firehouse was constructed on Cornell Avenue near the school, complete with a bell tower. Albany's first volunteer fire department proudly poses here with its hand-drawn hose carts, the city's first fire equipment. Andy Andersen, a member of the department, recalled, "The first feller that seen the fire ran for the bell and rang it. Then we all grabbed aholt [sic] of the cart and ran!" Fire chief Tom McCourtney appears at the far right, next to assistant fire chief George Browne. (Courtesy Albany Fire Department, ALHC.)

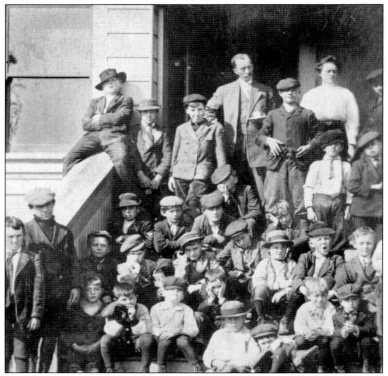

Judging by the expressions of these schoolchildren, the "Boys of Albany"— the title given this photograph—would rather be anywhere but at school. The group is pictured on the steps of Albany School in 1910. Joe Villa, who attended the school soon after, remembered the excitement whenever the bell at the adjacent firehouse would ring—all the boys would take off running, sometimes pulling hose carts, and "there was no more school that day." (Courtesy Albany Fire Department and ALHC.)

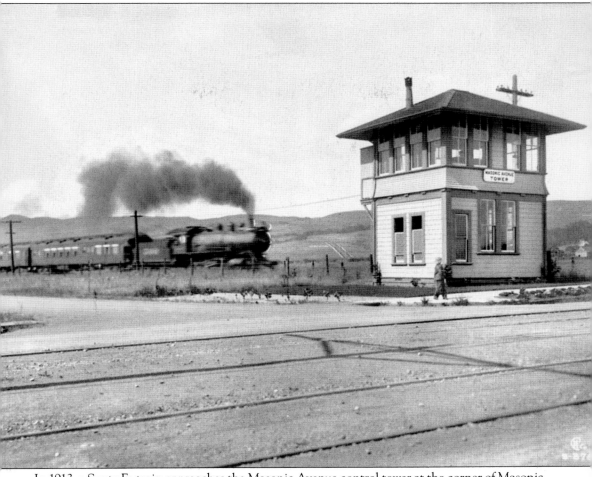

In 1913, a Santa Fe train approaches the Masonic Avenue control tower at the corner of Masonic and Solano Avenues (the current site of the BART tracks). Originally, the California and Nevada Railroad ran along this route. In the early 1900s, Albany officials touted the transportation systems, including the Santa Fe line, the Southern Pacific electric trains, and the Oakland Traction Company streetcars—which traveled to Oakland, Alameda, or San Leandro for 5¢—as one of the city's big assets. In later years, the Santa Fe tracks would become a line of division within the city. "If you lived above [east of] the tracks you were high class; if you lived below [west of] the tracks you were inferior," recalled Eugene Hellwig, a longtime Albany resident who grew up in a house west of the tracks in the 1930s. (Courtesy Vernon Sappers, ALHC.)

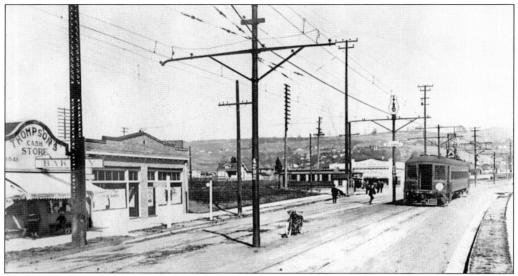

In 1915, the new Albany City Hall and adjoining Albany Library were located on Solano Avenue next to Thompson's Store, between Adams Street and San Pablo Avenue. In this image, the police department's motorcycle is parked between the tracks of the "Red Train," which had started running about three years earlier, making travel to San Francisco much more convenient. City brochures from the time state that the trip took 45 minutes and cost 10¢ each way, with another 10¢ for the ferry trip across the bay. (Courtesy Ed McManus, ALHC.)

A view west from Stannage Avenue reveals a nearly bare Albany Hill in 1916. Joe Sampietro, who lived nearby, recalled sliding down the dry grass from the top of the hill to Adams Street in a wooden box "toboggan." He also remembered how wet the area around the base of the hill and San Pablo Avenue were in the winter. "You almost had to have hip boots to cross San Pablo," he said. "All the water drained down toward the creeks." (Courtesy Albany Fire Department, ALHC.)

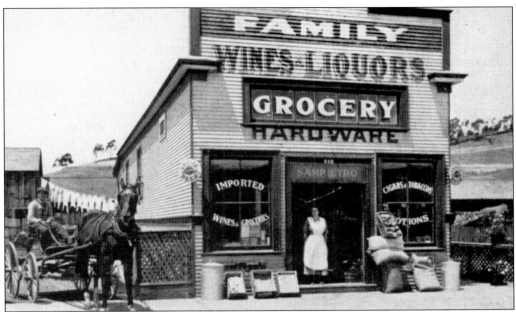

Joe and Nora Sampietro, pictured above about 1909, are in front of their father's grocery store at 818 San Pablo Avenue. The store was among those that catered to the many Italian families escaping San Francisco after the 1906 earthquake. When not helping out in the store, Joe was playing bocce ball in the adjacent alley or hunting quail and rabbits above Santa Fe Avenue in "no man's land." "I remember nothing but wheat fields," he said. "You could almost count the houses on your fingers. . . . When you wanted to get on the [San Pablo Avenue] streetcar at night, you'd have to have a lantern to get the attention of the motorman." The Albany Italian Band, led by Prof. Cheli Rudolfo, poses below on the steps of the school in 1918. (Above courtesy Albany Fire Department; below courtesy Albany Fire Department, ALHC.)

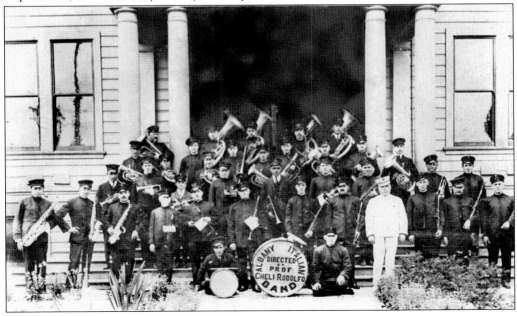

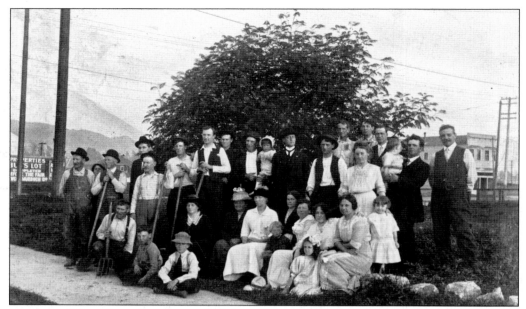

Members of the Albany Improvement Club and Women's Improvement Club, the city's first two volunteer service groups, clean San Pablo Avenue and Main Street (Solano Avenue) about 1912. Another effort of the groups was planting geraniums to help beautify Albany's streets. (Courtesy Frank Roberts Jr., ALHC.)

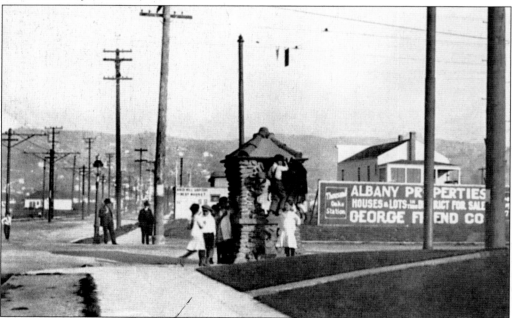

This fountain, located at the corner of San Pablo and Solano Avenues, was built by the Albany Improvement Club and presented to the city. It not only provided water for travelers but became a popular spot for water fights among children. Seen here about 1913, the intersection that would later become a central hub of Albany's business district is still mostly undeveloped. The large sign in the background ensures that passersby know that nearby property is for sale. (Courtesy ALHC.)

Built about 1912 near the Santa Fe Avenue intersection, the above home was one of the first residences on Marin Avenue. Houses such as these helped Albany promoters entice city residents to relocate to what they dubbed "The Bungalow City." "The modern bungalow strongly appeals to the person of moderate means, and is fast becoming the favorite home for our residents on the east bay shore," states promotional material from the time. "The city dweller, educated to the apartment house plan of rooms on the one floor . . . [with] overhead or adjoining noises, also objectionable neighbors, readily realizes that a bungalow on the hillside or level plot of ground would be a luxury." The house in the 600 block of Adams Street, pictured at right around 1913, must have been a luxury to Margaret Toreky and her father, Joseph, who had first lived in a tent, then a tiny one-room house with a leaky roof on Adams Street. (Above courtesy ALHC; at right courtesy Margaret Toreky Corey, ALHC.)

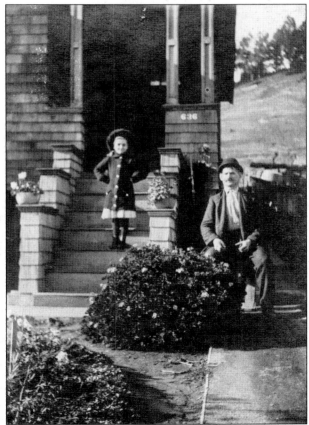

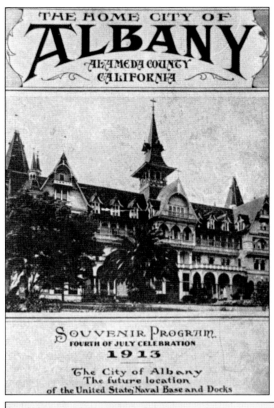

THE HOME CITY OF
ALBANY
ALAMEDA COUNTY
CALIFORNIA

SOUVENIR PROGRAM
FOURTH OF JULY CELEBRATION
1913

The City of Albany
The future location
of the United States Naval Base and Docks

The 1913 Fourth of July celebration in Albany was a grand event. Hoping to attract new residents, city promoters produced this souvenir program, which featured an image of the area's most impressive building, the Peralta Park Hotel, on the cover. The title also announced with certainty the coming of a U.S. naval base—a hope that was not to be realized. The navy located in Alameda instead. (Courtesy Ed McManus, ALHC.)

"ALBANY, where climate, conveniences and courtesy cancels competition" was a slogan that appeared inside the 1913 Fourth of July souvenir program. Also included was this rare photograph of the Albany waterfront. The shoreline area between Fleming's Point and Cerrito Creek was enthusiastically but prematurely named as the location already chosen for the naval base. (Courtesy Albany Fire Department, ALHC.)

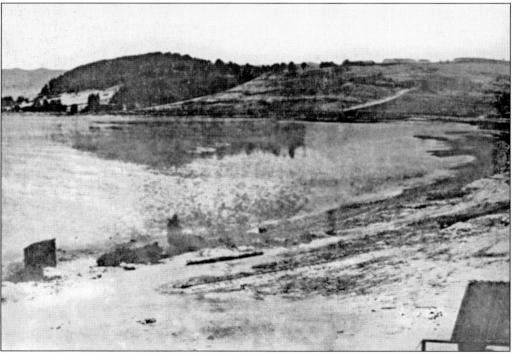

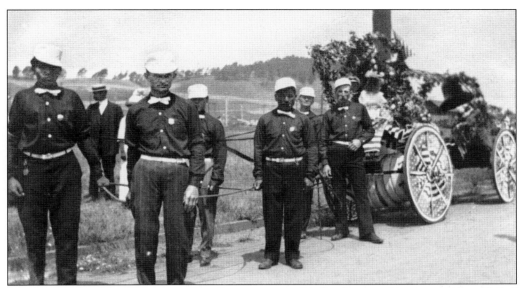

Members of the Albany Volunteer Fire Department pull a flag-festooned hose cart, identified as Hose and Ladder Truck No. 1. The group of six comprised the winning team in a race held during the city's 1912 Fourth of July celebration. (Courtesy Albany Fire Department, ALHC.)

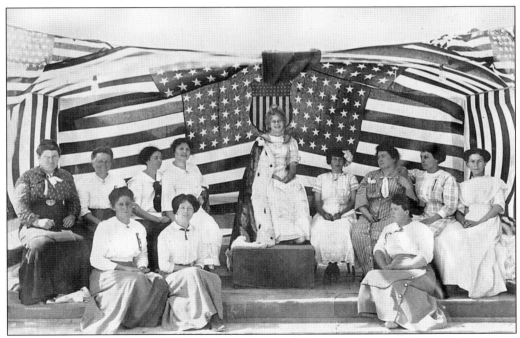

Francis Olson (Mrs. Ray Winfield), seen in the center of the second row, was chosen as the Albany Fourth of July Queen in 1913. She is seated with her court at the city's celebration. (Courtesy Albany Fire Department, ALHC.)

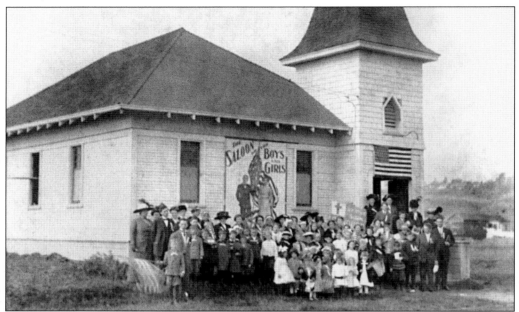

In the photograph above, the congregation of Albany Methodist Church poses on Stannage Avenue about 1918. A Prohibition sign, "The Saloon or the Boys and Girls," is displayed prominently on the front of the church, which was founded in 1907. The photograph below, taken in 1913, shows Chapel Immanuel (later known as the First Baptist Church of Albany) and its congregation at its original location on the corner of Brighton and Stannage Avenues. The two churches (today Albany United Methodist Church and the Church on the Corner, respectively) are the oldest in Albany and continue to operate, along with many other religious organizations. (Above courtesy Albany Methodist Church, ALHC; below courtesy Alyce Berndt, ALHC.)

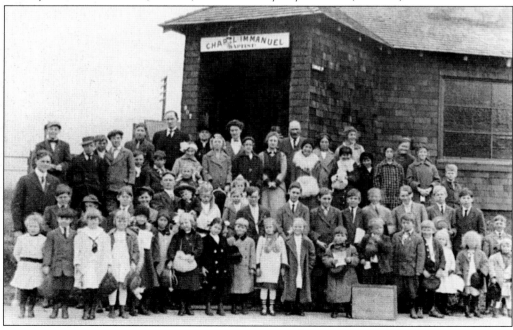

Ana Marie Hansen and her son Robert pose in 1912 in front of their home in the 1000 block of Curtis Street (then called Christiana Street). The house was built in the early 1900s. Robert later married Linea Griffith, who lived across the street. (Courtesy Robert and Linea Marie Hansen, ALHC.)

The year 1915 was a big one for the Albany Volunteer Fire Department. A new firehouse was built at the corner of Washington and San Pablo Avenues, the city's first motorized fire truck was purchased, and Thomas McCourtney was appointed the first full-time fireman. Here a group of enthusiastic firemen and residents gather in front of the firehouse with the recently delivered vehicle, a state-of-the-art Seagrave Combination chemical-hose-and-ladder truck. The truck, which later became known as "Old Betsy," was first displayed at the Panama Pacific International Fair in San Francisco before being delivered to Albany. (Courtesy Albany Fire Department, ALHC.)

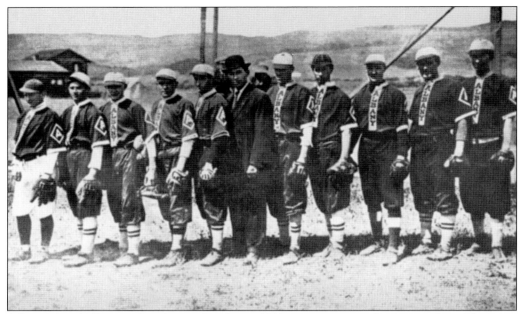

Albany's baseball team played every Sunday in 1913, a winning year for the members. The team consisted of 10 players, pictured above and identified in a city brochure as follows: B. Lloyd, L. Pierotti, F. Bankeno, D. Lloyd, F. Fraitas [*sic*], A. Jackson, F. Gleaser, H. Leonard, P. Lloyd, and O. Parquet. (Courtesy Albany Fire Department, ALHC.)

By 1916, Albany was growing rapidly and its one grammar school was already crowded. A successful bond election provided funds for a new auditorium at the school, seen here facing Cornell Avenue in 1917. The funds also allowed for a new grammar school—Marin School—which was built at the corner of Santa Fe and Marin Avenues in 1917. (Courtesy Albany Fire Department, ALHC.)

Three

THE 1920S

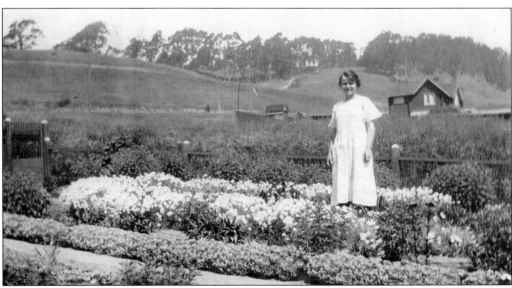

Kathleen Watkinson stands in the garden of her Albany home around 1923. She arrived from England in 1920 to marry her fiancé, John Watkinson, who had settled near his uncle in Albany. At this time, the city still had wide open spaces, especially on Albany Hill, which is seen in the background. Kathleen's daughter Mary Wallmann recalled the wildflowers—lupine and poppies— that used to fill the hillside and open fields in the spring. "You couldn't even see the grass," she said. "It was all blue and gold." Kathleen Watkinson worked as an Albany librarian during the 1920s and again from 1948 to 1962. Mary Wallmann, who still lives in Albany, was also a librarian, working for many years at Albany High School. (Courtesy Mary Wallmann, ALHC.)

Students at Cornell School pose on the steps in the early 1920s. (Courtesy Albany Unified School District, ALHC.)

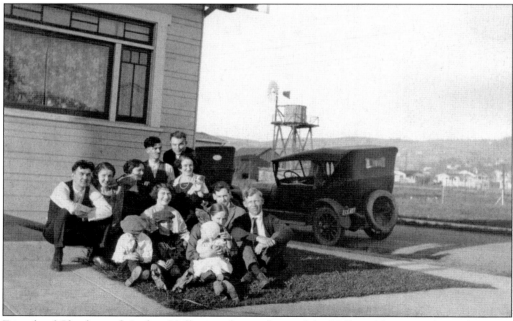

Friends of Charles and Audrey Hellwig gather in front of the Hellwigs' home in the early 1920s. Located on the corner of Marin Avenue and Evelyn Street, the lot was given to Audrey and Charles as a wedding present from Martha and Ernst Hellwig, who lived next door. A water windmill and large open field are visible in the background, between Evelyn Street and Masonic Avenue. (Courtesy Eugene Hellwig, AHS.)

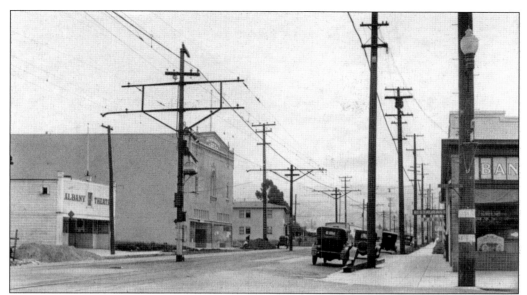

Looking east from the intersection of San Pablo and Solano Avenues, this late-1920s view includes the first Albany Theatre (left). The tall building, which would become the new home of the theater in 1935, was built in 1926 and at this time served as the Italian Social Hall. It consisted of two stories, five rooms, and a ballroom. Tony Cola, who was born in Ocean View (Albany) in 1909, remembered his father serving as an officer for the Italian lodge that held meetings in the building. The site later became a pool hall. (Courtesy Albany Fire Department, ALHC.)

This portion of the 1500 block of Solano Avenue, pictured in the 1920s, might have become part of Albany, except for a dispute that occurred in 1908. Workers at the Spring Construction Camp—located east of Neilson Street and north of Solano—were against incorporation of Ocean View (Albany), so to ensure success, those in favor of it simply eliminated the area from the proposed new city. The result was the odd zigzag boundary still present today along Albany's eastern border. (Courtesy Albany Fire Department, ALHC.)

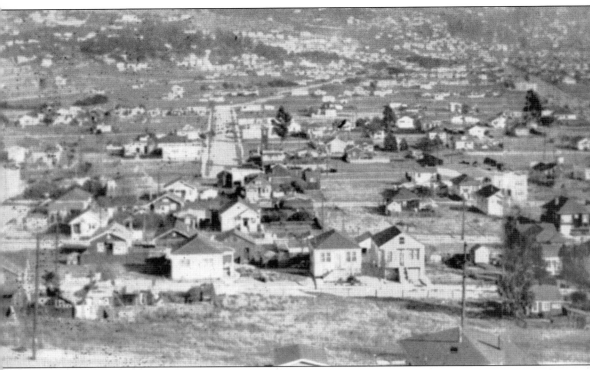

This view of Albany, taken from Cerrito and Washington Streets, shows the state of the city's development in the 1920s. The Red Train (see arrow), part of the Ninth Street Loop,

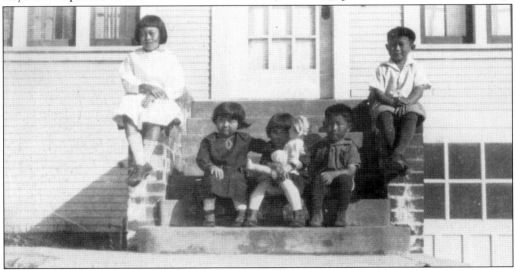

Members of the Nishi family, among the few Japanese American residents of Albany at the time, pose with friends on the steps of their home in the 1100 block of Santa Fe Avenue in the late 1920s. Seen here from left to right are June Nishi, two unidentified people, Taka Nishi, and Yoshi Nishi. The family was later forced to leave Albany during World War II. They were at an Arizona internment camp when they received the news that Taka Nishi, part of the famed 442nd Regiment, was killed in Italy while serving in the U.S. Army. (Courtesy Jewel Okawachi, AHS.)

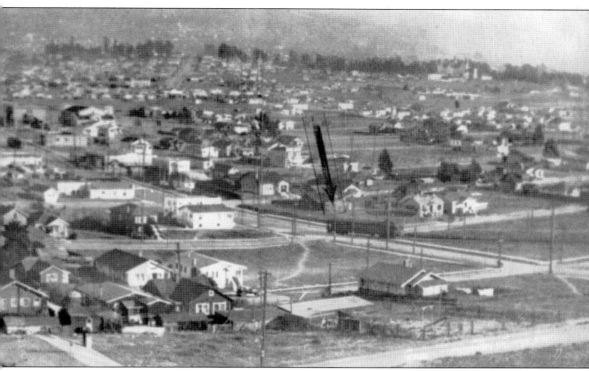

heads into the curve at the corner of Madison and Solano Avenues. (Courtesy Albany Fire Department, ALHC.)

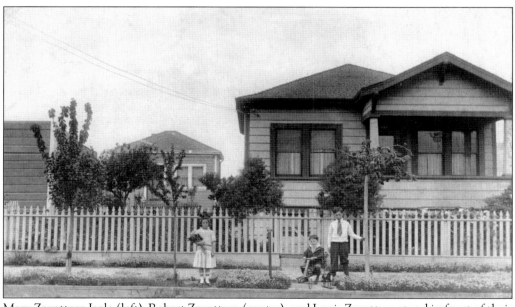

Mary Zavattaro Isola (left), Robert Zavattaro (center), and Louis Zavattaro stand in front of their home in the 800 block of Evelyn Street in 1922. (Courtesy Angelina Accornero, ALHC.)

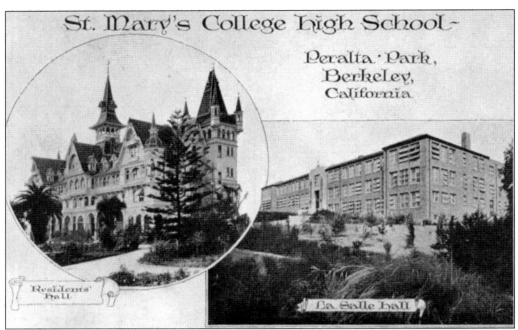

In 1927, the high school department of St. Mary's College moved from Oakland to Peralta Park and into the newly built De La Salle Hall, pictured in this postcard. The old Peralta Park Hotel, at this time used as a residents' hall, burned in 1946 and the top two floors were razed. The beloved Palace was finally completely demolished in 1959. (Courtesy De La Salle Institute.)

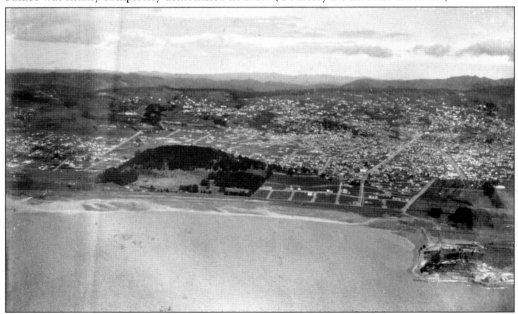

This 1928 aerial view of Albany's waterfront reveals a sparsely developed Albany Hill to the left and a wide-open Gill Tract and unaltered Fleming's Point to the right. The photograph predates the construction of the Eastshore Highway in the 1930s, which would later be replaced by the Eastshore Freeway. (Courtesy California State Lands Commission.)

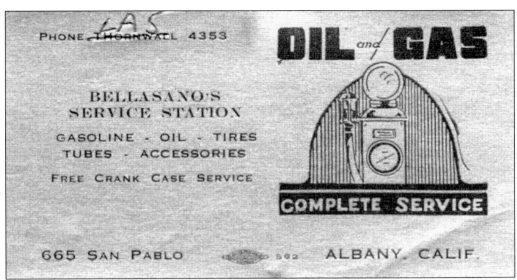

The Bellasano family of Albany began operating a service station at 665 San Pablo Avenue in 1927. On this early business card, the telephone prefix has been changed from THornwall to LAndscape. (Courtesy Carol Gilman, ALHC.)

Loraine Barbagelata (left) and her friend Ruth Taviera sit on the steps of Loraine's home in the 1200 block of Garfield Avenue in the 1920s. Loraine's mother, Rose Marshall (Machado), grew up just down the street (see page 16) and moved to this house after she married. Today the home is occupied by Loraine's son Tom Adame and his wife, Susan, who raised their own son, Alex, at the property. Alex was the sixth generation of the family to reside on Garfield Avenue. (Courtesy Rose Barbagelata, ALHC.)

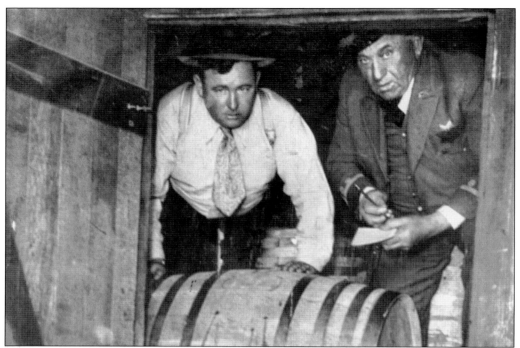

"Roll out the barrel" had a different meaning during Prohibition, as evidenced by the above 1920s photograph. Deputy Marshal Stanley Williams (left) and Marshal John Glavinovich confiscate barrels from an Albany wine cellar. Glavinovich, appointed marshal in 1912, became Albany's first chief of police in 1927. Williams went on to become chief of police in the early 1940s. Below, Albany officials pour wine onto the street in the late 1920s. (Both courtesy Gerald Browne, ALHC.)

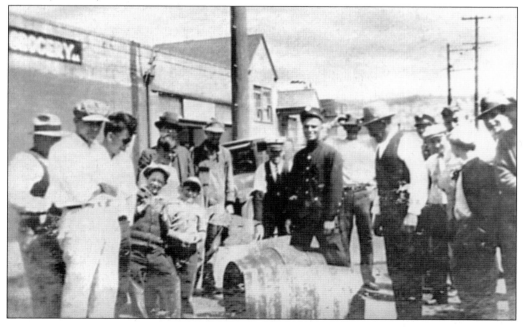

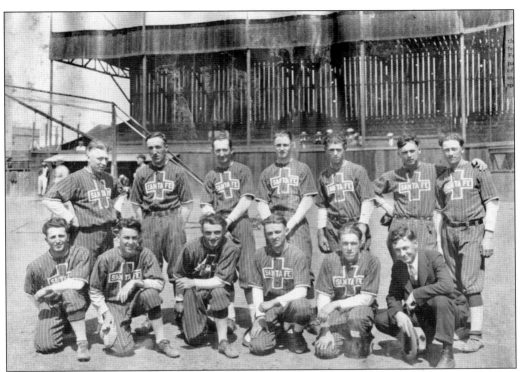

An Albany baseball team gathers for a group photograph in the 1920s. (Courtesy Albany Fire Department, ALHC.)

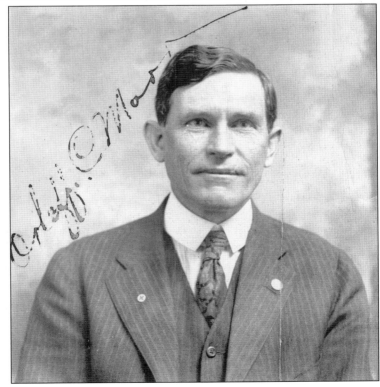

Orloff C. Marr was one of Albany's longest-term mayors. First elected in 1916, he served as mayor until 1924. Marr also chaired the Red Cross auxiliary of Albany. During this time, his home was in the 1600 block of Marin Avenue, where he lived with his wife, Mary, and three children. (Courtesy Marr family, ALHC.)

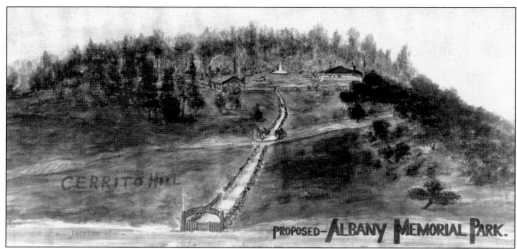

An artist has depicted the "Proposed Albany Memorial Park" in the 1920s. The entrance to the park is shown at the intersection of Clay and Jackson Streets, on the eastern slope of Albany Hill (then Cerrito Hill). A Ferris wheel, picnic tables, fountain, and gazebo are drawn as features. The site may have originally been considered as an alternative location to the present-day Memorial Park, located between Pomona and Carmel Avenues. (Courtesy Raymond Raineri, AHS.)

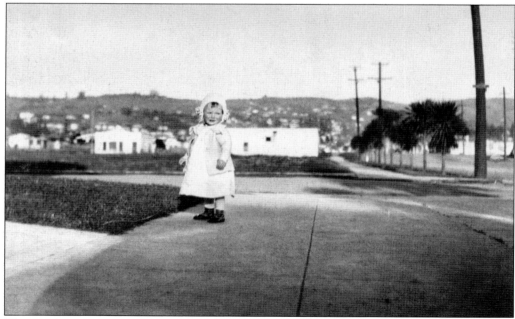

The northwest corner of Marin Avenue and Evelyn Street is seen about 1924. Behind this unidentified toddler, the view looks east on Marin Avenue. The open field in the background became the site of the Humboldt (later Albany) Hospital in the late 1920s and then the Albany Community Center and Albany Library in 1994. (Courtesy Eugene Hellwig, AHS.)

Four

THE 1930s

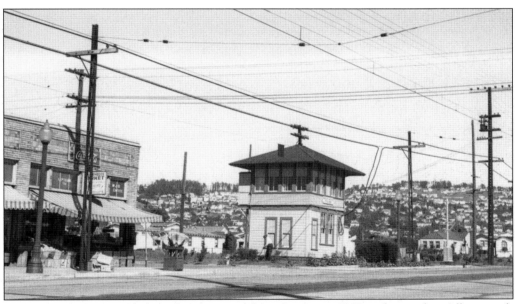

Deoneceous "Danny" Chelemedos emigrated from Greece in 1909 and moved to Albany with his wife, Mimmi, in 1926. The couple bought a home on Key Route Boulevard, constructed the pictured building on the northwest corner of Masonic and Solano Avenues, and opened the Chelemedos Market here in 1927. Don Chelemedos, one of five boys in the family, began working in the store at age six, eventually taking over the business in the late 1950s and running it until 1981. "It was a neighborhood store—a real gathering place," he recalled. Seen here in 1939, the store stands directly across the street from the Masonic Tower, which at this time still dominated the intersection (compare to page 25). Today the former market houses an arts gallery. (Photograph by Ralph Demoro; courtesy John Harder Collection.)

By the 1930s, Albany's two grammar schools, Marin and Cornell, were well established. Above, second-grade students from Cornell pose on the auditorium steps in 1932. Eugene Hellwig appears in the second row, far left. Below, a Marin kindergarten class gathers in 1933 at the school entrance on the corner of Santa Fe and Marin Avenues. Mary Wallmann stands in the sixth row, far right. Students from this time recall the great rivalry that existed between the two schools, which competed against each other in sporting events. "Corny Cornell" and "Muddy Marin" were the terms each used for the other—phrases that would stick for decades. (Above courtesy Eugene Hellwig, AHS; below courtesy Mary Wallmann, ALHC.)

In the 1930s, each school had a supervised after-school playground program. Above is a bulletin-board sign about Cornell School's program. Below is a similar poster describing the playground program at Marin School. (Courtesy Albany Recreation and Community Services, AHS.)

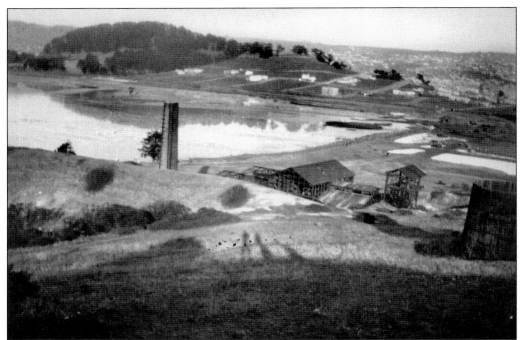

When the above photograph was taken in 1930, Albany's waterfront had not changed that much from the time when the powder companies were operating in the area. Remnants of these operations can be seen in the foreground on Fleming's Point. The status quo, however, would soon change. One of the first big changes occurred in the late 1930s when the Eastshore Highway was constructed. Below, a view from Albany Hill shows the project underway. (Above courtesy Walter Ringbom, ALHC; below courtesy Albany Fire Department, ALHC.)

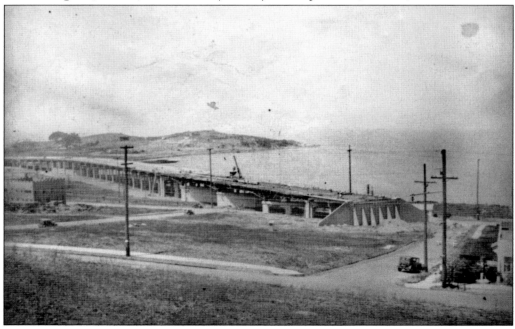

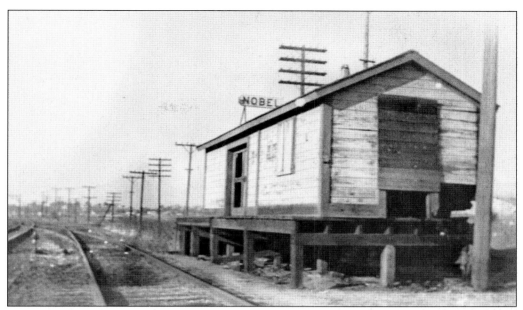

November 7, 1930, was the date of Albany's famous train robbery, which occurred at the abandoned Nobel Train Station on the west side of Albany Hill. The station, once used as a loading platform by explosives manufacturing companies, was named after Alfred Bernard Nobel, the inventor of dynamite. Members of the notorious Frank Smith Gang boarded a Southern Pacific passenger train early in the morning in Berkeley and forced the engineer to stop at the old depot, where they proceeded to steal thousands of dollars destined for Contra Costa County companies. The thieves escaped but were later apprehended. (Courtesy Louis Stein, ALHC.)

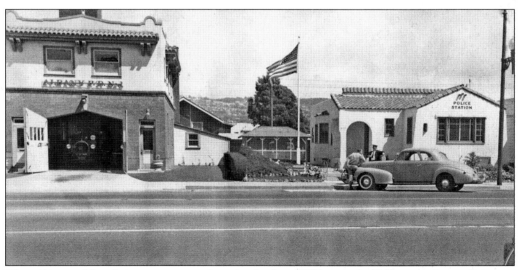

The police and fire departments, seen here in the late 1930s or early 1940s, were located next to each other along San Pablo Avenue near Washington Street. In between the two buildings was a fish pond built by the firemen, as well as a bird aviary. (Courtesy Albany Fire Department, ALHC.)

University Park was a popular location for baseball games in the 1930s. Today the site is the location of the Western Regional Research Center of the Agricultural Research Service. (Courtesy Albany Fire Department, ALHC.)

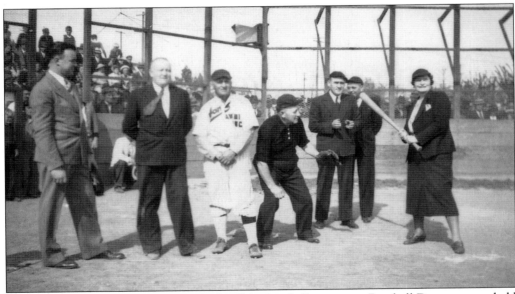

A group of prominent citizens helps kick off the baseball season on Baseball Day, an event held at Albany's University Park, in the late 1930s. Pictured here from left to right are Charlie Tye, a well-known sports announcer who acted as master of ceremonies; Louis Griffing, manager of the Braun Mattress team; Jake Nora, manager of the Albany Merchants team; Albany mayor O. C. Yenne; Albany judge Louis J. Hardie; fire chief Carl Ahlgren; and Beatrice Raymond, a prominent businesswoman active with the Albany Chamber of Commerce. (Courtesy AHS.)

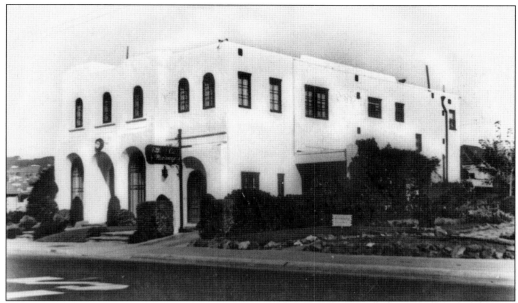

The James J. Ellis Mortuary (first known as the Ellis-Guay Mortuary) opened in 1932 at 727 San Pablo Avenue and operated in Albany for many years. Later rebuilt, it became the Ellis-Olson Mortuary, operated by May Ellis-Olson and her husband, Harold Olson. (Courtesy ALHC.)

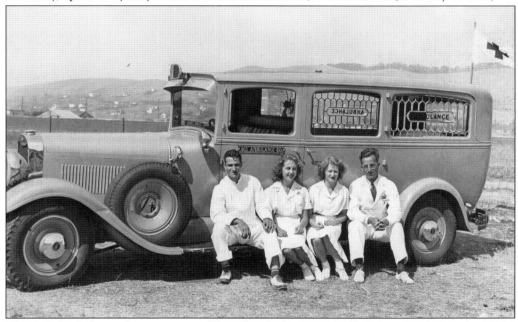

The Ace Ambulance Company was affiliated with the James J. Ellis Mortuary during the 1930s. According to Bob Walkup—who later ran the mortuary after working there with his grandmother May Ellis-Olson—it was not uncommon at this time for ambulance services to be connected with mortuaries and to show up at the scenes of automobile accidents. Women were employed as "lady attendants" whose jobs were to comfort family members. The Ace Ambulance crew is shown in the late 1930s. (Courtesy May Ellis-Olson, AHS.)

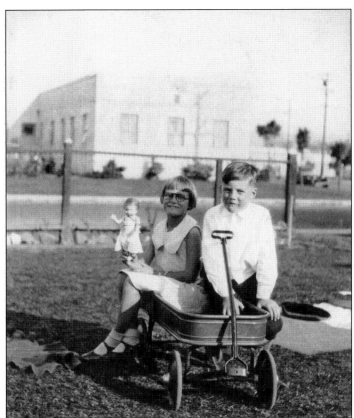

Eugene Hellwig and his sister Audrey Jean Hellwig play with their wagon in the backyard of their house at Marin and Evelyn Avenues around 1930. Their play was by no means restricted to the yard—Eugene recalls roaming all over town and riding his bike down the slopes of Albany Hill. Behind them is Humboldt Hospital, which was built in the late 1920s on the site of today's Albany Community Center. The children's father, Charles Hellwig, was a plumber who helped construct the hospital. (Courtesy Eugene Hellwig, AHS.)

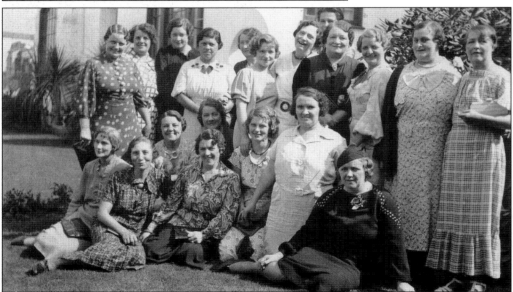

The Albany Tent of the Maccabees first began as a service group in 1912. Seen here during the 1930s is the sewing club of the Ladies Hive, which at this time was known for its social activities and its assistance to the needy during the Depression. (Courtesy May Ellis-Olson, AHS.)

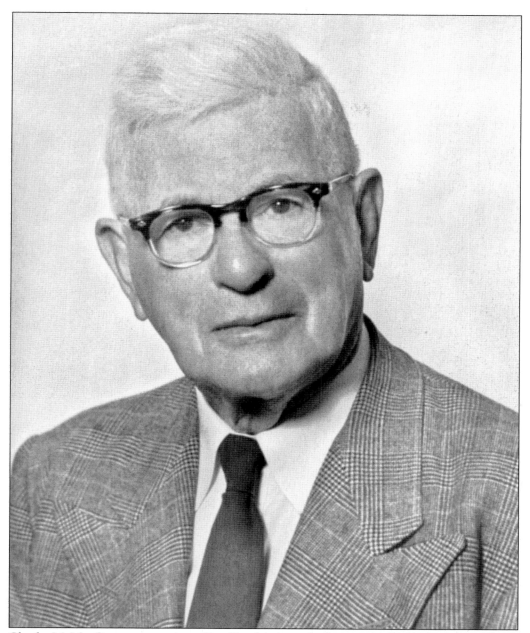

Charles M. MacGregor, a prominent East Bay developer, built more than 1,500 homes in Albany beginning in the late 1920s and continuing through the early 1940s. Pictured in his later years, he became known as "One-Nail MacGregor." Over the years, the nickname has come to have several meanings, according to MacGregor's grandson Ingraham Read Jr. One story was that MacGregor himself put one nail somewhere in every house his company built. Another was that he would hand all job applicants one nail and a hammer—part of their success in landing a job depended on how well they drove that nail. The most common story relates to quality: that he added one nail more than his competitors to each home. MacGregor's competitors told it differently: that he put in one nail less. (Courtesy AHS.)

MacGregor built this commercial building on the northwest corner of Solano and Carmel Avenues in the mid-1930s. By this time, so much of his business was in Albany that he had moved his company here from Oakland, setting up the office of MacGregor Homes at 1391 Solano Avenue (visible on the left, next to the Bo-Kay Gift Shop). He was known for keeping his workers employed year-round through the rainy season—especially rare and appreciated during the Depression. (Courtesy AHS.)

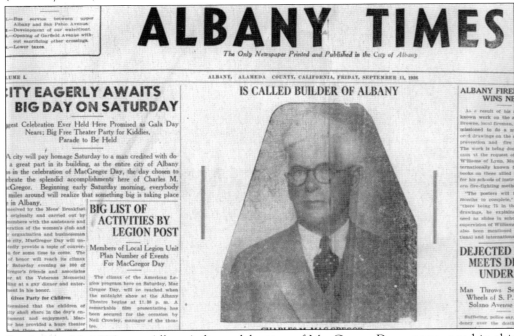

September 12, 1936, was Albany's first celebration of MacGregor Day—announced in this front-page *Albany Times* article—an event that would be held every year for nearly the next two decades. Among the many activities of the day were a parade, athletic events at Memorial Park, a watermelon-rolling contest, a band concert, and a "women's parking contest" on Solano Avenue. The highlights, however, were the free Albany Theatre tickets and ice cream Charles MacGregor provided for Albany schoolchildren. (Courtesy AHS.)

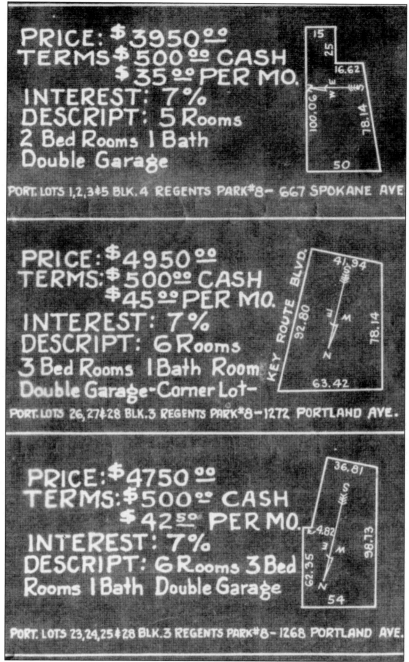

PRICE: $3950.00
TERMS $500.00 CASH
$35.00 PER MO.
INTEREST: 7%
DESCRIPT: 5 Rooms
2 Bed Rooms 1 Bath
Double Garage

PORT. LOTS 1,2,3&5 BLK. 4 REGENTS PARK#8- 667 SPOKANE AVE

PRICE: $4950.00
TERMS: $500.00 CASH
$45.00 PER MO.
INTEREST: 7%
DESCRIPT: 6 Rooms
3 Bed Rooms 1 Bath Room
Double Garage-Corner Lot-

PORT. LOTS 26, 27&28 BLK. 3 REGENTS PARK#8-1272 PORTLAND AVE.

PRICE: $4750.00
TERMS: $500.00 CASH
$42.50 PER MO.
INTEREST: 7%
DESCRIPT: 6 Rooms 3 Bed
Rooms 1 Bath Double Garage

PORT. LOTS 23,24,25&28 BLK.3 REGENTS PARK#8 - 1268 PORTLAND AVE.

This sheet of new home listings, from Charles MacGregor's files, shows that two- and three-bedroom MacGregor homes on Spokane and Portland Avenues were first priced between $4,000 and $5,000. In the market of the early 1930s, just $500 (10 percent) down was required, and monthly payments ranged from $35 to $45. Today many Albany MacGregor homes sell for well over $500,000, and one extensively upgraded three-bedroom on Ordway Street was listed in 2007 for $1.1 million. (Courtesy AHS.)

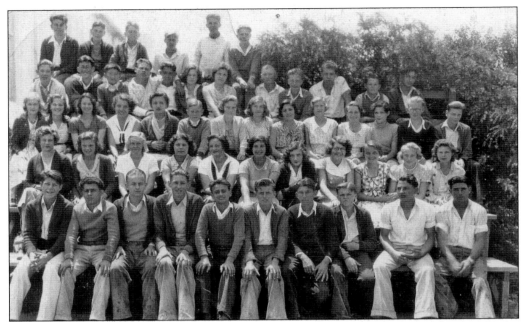

During the 1920s, Albany's population continued to expand, and by the end of the decade, the grammar schools were again becoming crowded. In 1928, Herbert Hoover Junior High School was built at Pomona Avenue and Thousand Oaks Boulevard for students in the seventh, eighth, and, later, ninth grades. The school's ninth-grade students pose in May 1932. (Courtesy Jewel Okawachi, AHS.)

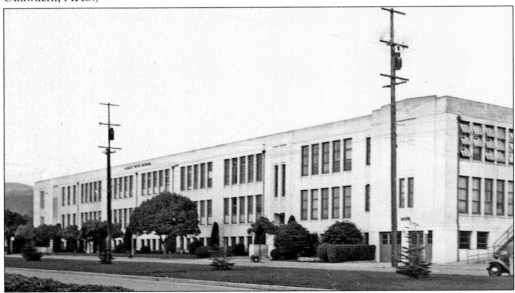

For many years, Albany lacked a high school, so older students were typically sent to the schools of neighboring cities. In the late 1920s, a tense division existed in the community over whether Albany should establish its own high school or become part of the City of Berkeley to gain access to Berkeley schools. The latter suggestion was voted down, and by the mid-1930s, the original Albany High School, above, was under construction. (Courtesy Albany Unified School District, ALHC.)

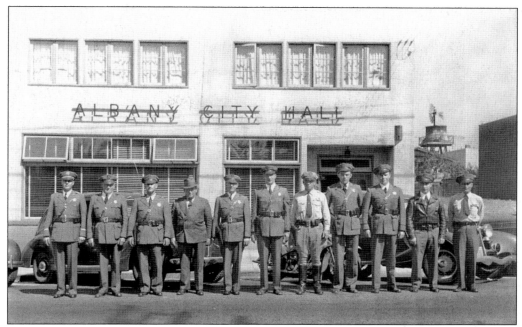

The Albany Police Department gathers in front of the old city hall on Solano Avenue in the late 1930s or early 1940s. (Courtesy Albany Fire Department, ALHC.)

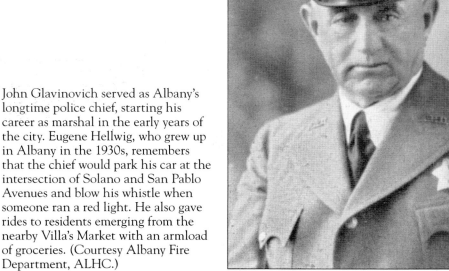

John Glavinovich served as Albany's longtime police chief, starting his career as marshal in the early years of the city. Eugene Hellwig, who grew up in Albany in the 1930s, remembers that the chief would park his car at the intersection of Solano and San Pablo Avenues and blow his whistle when someone ran a red light. He also gave rides to residents emerging from the nearby Villa's Market with an armload of groceries. (Courtesy Albany Fire Department, ALHC.)

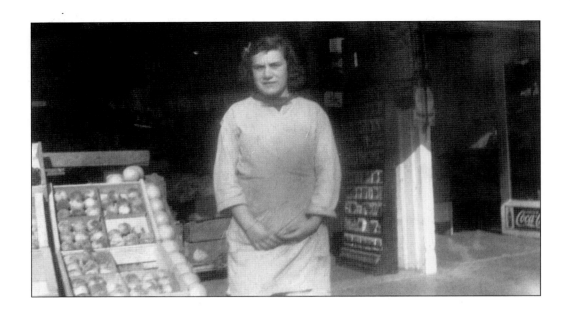

The late Mary Carlevaro (Neylon), a longtime owner of Mary and Joe's Sporting Goods, was born in Albany in the mid-1920s. Above, in the late 1930s, she stands in front of her parents' store (then a grocery) at 913 San Pablo Avenue, where she began working at the age of 12. Below, unidentified clerks are pictured inside the store in 1937. Along with her husband, Pat Neylon, and her brother Joe Carlevaro, Mary eventually took over the business, selling bowling supplies for a time before settling on sporting goods. The store, one of Albany's oldest businesses, still operates today in the same building in which Mary was born. (Both courtesy Neylon family, AHS.)

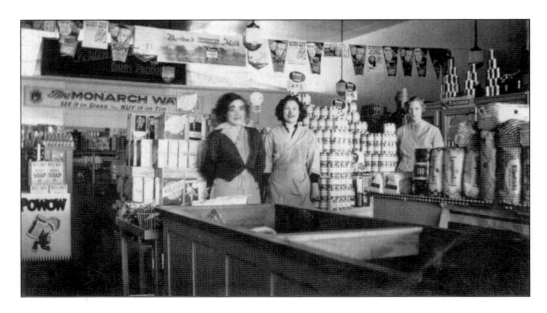

Jewel (Nishi) Okawachi, who would later become an Albany mayor and city council member, grew up in Albany, first living on Santa Fe Avenue. Her father, a San Francisco dentist, built a house in the 1100 block of Curtis Street and moved the family there when Okawachi was just one year old. She still lives in the house today. Okawachi went on to own and operate a typesetting business on San Pablo Avenue. Pictured above in the driveway of her house in 1936 are, from left to right, unidentified, Okawachi, Phyllis Pemberton, and Janet Pemberton. The house of Albany's first mayor, Frank Roberts, is visible in the background to the right. Below, Okawachi and her father, Chotoku Nishi, enjoy a day at the beach near Fleming's Point (near today's Golden Gate Fields) in 1936, when swimming was common there. (Both courtesy Jewel Okawachi, AHS.)

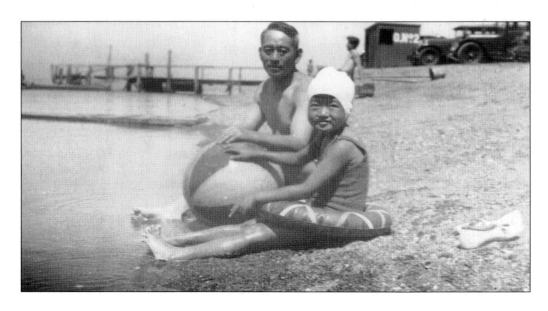

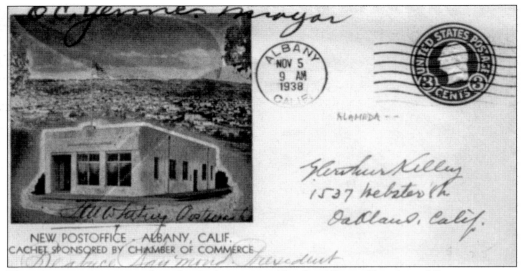

This commemorative envelope (cachet), sponsored by the Albany Chamber of Commerce, was produced for the new Albany Post Office, which opened at its present location at 1191 Solano Avenue in 1938. The envelope was signed by Mayor O. C. Yenne, chamber of commerce president Beatrice Raymond, and the postmaster, F. M. Whiting. The necessary postage was just 3¢. (Courtesy Raymond Raineri, AHS.)

Susie Tanaka Krieder was born in Japan in 1888 but grew up in San Francisco. There she eventually worked with her future husband, Thomas Krieder, and Frank Roberts, who would later become mayor of Albany. At Roberts's suggestion, she and her husband moved to Albany in 1909 and built one of the first homes on Cornell Avenue, near the old Cornell School. Susie (center) poses with her four children outside their house in the 900 block of Cornell in the 1930s. (Courtesy Jewel Okawachi, AHS.)

The price of automobiles in the 1930s is almost unimaginable today, but during the Depression, many people could not afford to buy a car. This October 9, 1936, advertisement for Murphy's Chevrolet at 916 San Pablo Avenue lists reconditioned cars on sale, from a $55 eight-year-old Nash to a $645 two-year-old Buick. (Courtesy AHS.)

Hon. Louis Hardie moved to Albany in 1930, serving first as the city attorney until the city council appointed him to the Albany Justice Court in 1937. He was subsequently elected four times. Hardie transferred to the Berkeley Albany Municipal Court when the courts were reorganized in 1950 and served as a judge in this capacity until his retirement in 1958. He and his son Laurence appear here at their home in the 1100 block of Curtis Street about 1934. Four generations of the Hardie family have now lived on Curtis Street. (Courtesy Hardie family, AHS.)

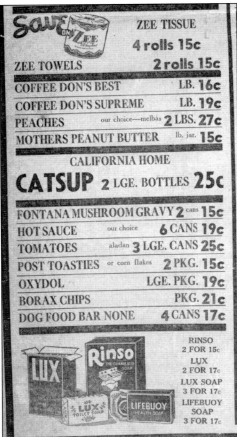

This advertisement for Don's Market, a grocery at the corner of San Pablo and Washington Avenues, appeared in September 1936. Coffee for 16¢ a pound and Post Toasties for 15¢ may seem like a bargain today but were likely expensive enough for consumers during the Depression years. "No one had any money," recalls Mary Wallmann, a child living in Albany at the time. Mary remembers her mother carefully cutting and sewing her father's old pants so they could next be worn by her brother. (Courtesy AHS.)

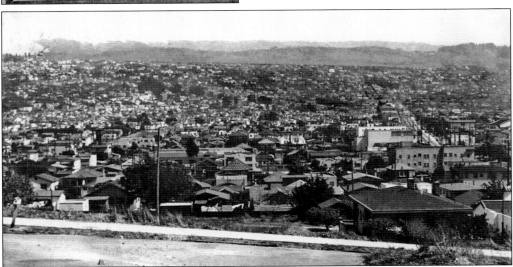

Taken from the corner of Washington Avenue and Polk Street, this 1937 photograph shows how much the city of Albany grew in its first 30 years (compare to page 18). A closer examination reveals that the Albany Theatre is advertising movies for 30¢. (Courtesy Albany Fire Department, ALHC.)

Five

THE 1940s

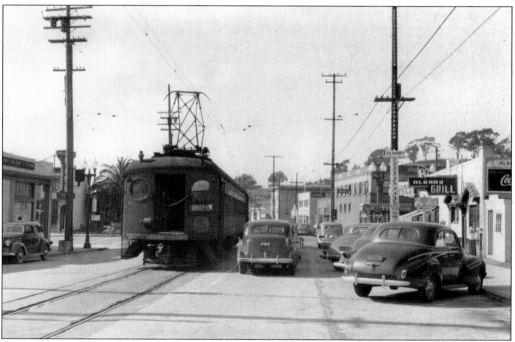

The run of Southern Pacific's East Bay electric cars, known as the Red Trains, came to an end in the early 1940s. At one time, this system transported commuters from several East Bay areas to the Oakland pier, where passengers boarded a ferry for San Francisco. In this *c.* 1940 westward view, a Ninth Street Line Red Train approaches the corner of San Pablo and Solano Avenues. (Courtesy Oakland History Room, Oakland Public Library, J. T. Graham Collection.)

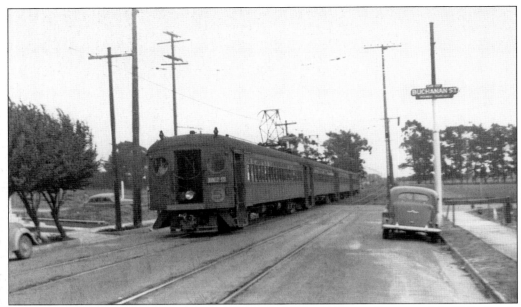

A Red Train is pictured at the intersection of Buchanan and Jackson Streets in July 1941, shortly before these trains ceased service. (Courtesy Louis Bradas, ALHC.)

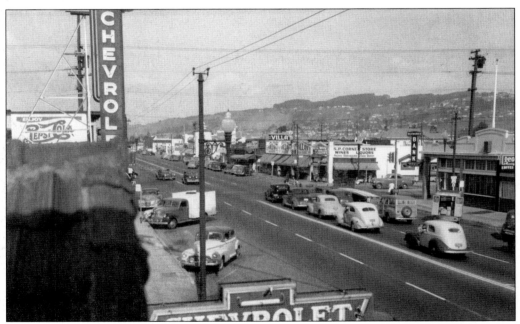

The intersection of San Pablo and Solano Avenues is seen in October 1947. What used to be a major cross street for streetcars and Southern Pacific electric trains is now a thoroughfare dominated by automobiles. The S. P. Corner Store on the northeast corner, once a place where passengers waited for the electric trains, now displays the sign "Pacific Greyhound Stage Depot." (Courtesy John Harder Collection.)

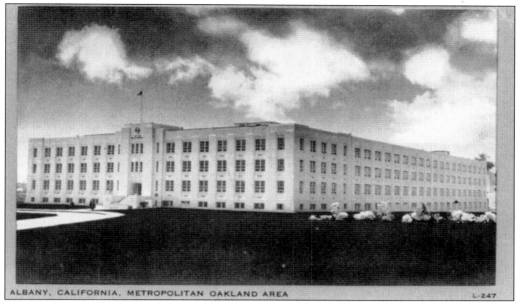

ALBANY, CALIFORNIA, METROPOLITAN OAKLAND AREA L-247

This *c.* 1940s postcard shows the newly constructed Western Regional Research Center, one of four regional laboratories established by the Agricultural Adjustment Act of 1938. Opened in 1940 on a portion of the original Gill Tract, the center became known for its 1950s–1960s pioneering research in frozen foods and other areas. Part of the Agricultural Research Service, a major research agency of the U.S. Department of Agriculture, the center still operates in the same location. (Courtesy Ed Clausen Collection, AHS.)

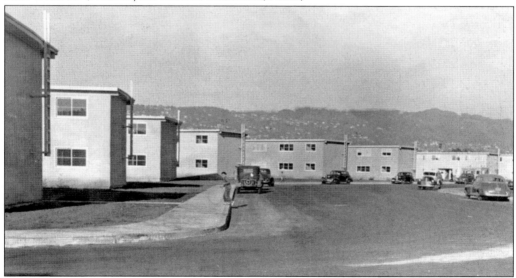

During 1943, the Federal Housing Authority began construction of the Codornices Village on a section of the Gill Tract—by this time owned by the University of California—and an even larger adjoining area in Berkeley. The site was rapidly developed into wartime housing for Richmond and Mare Island shipyard workers, personnel from the nearby Naval Landing Force Equipment Depot, and other war industry workers. This photograph displays the housing units in the Albany part of the village around 1945. (Courtesy Albany Fire Department, ALHC.)

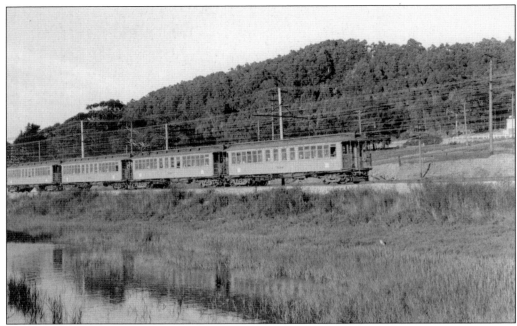

The Shipyard Railway, opened in 1943, was built to carry workers from Oakland and other East Bay locations to the Richmond shipyards during World War II. It was constructed largely of recycled and reused materials, including the trains. Here some old New York City Interborough Rapid Transit Company (IRT) cars, employed for the railway, run along the bay shore near the west side of Albany Hill about 1944. At one time, as many as 90 trains ran each weekday down Ninth Street through Codornices Village, transporting thousands of people to and from the shipyards. The railway was dismantled after the war. (Courtesy El Cerrito Historical Society, Louis Bradas Collection.)

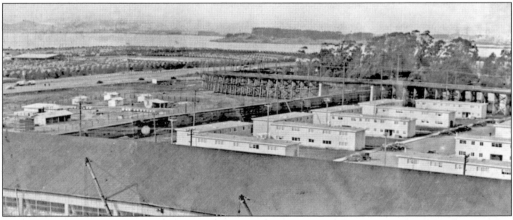

This rooftop view shows the Albany portion of Codornices Village around 1945. The wooden trestle, seen behind the buildings, was made from the old Key System ferry pier and allowed the Shipyard Railway to cross the Southern Pacific Railroad tracks. After the war, the village was used for veterans' housing. The Albany portion would eventually become the University Village for student families of the University of California, Berkeley. (Courtesy Albany Fire Department, ALHC.)

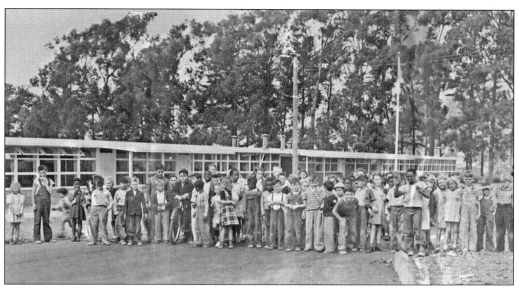

Codornices Elementary School, built by the Federal Works Agency, opened in 1944 to accommodate the children of Codornices Village. Part of the Albany Unified School District, the school had an enrollment of 860 students by 1945, surpassing that of Cornell Elementary (752) and Marin Elementary (741). Here Codornices students are pictured about 1944 at the school, which was located on Eighth Street. (Courtesy Albany Fire Department, ALHC.)

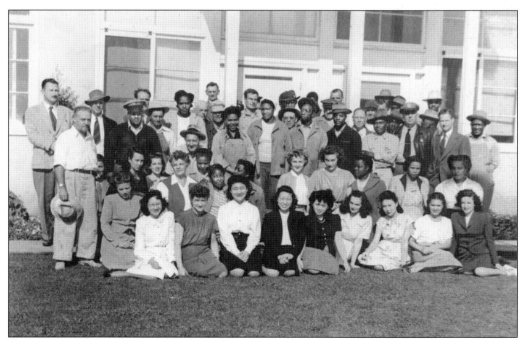

The employees of Codornices Village pose for a photograph in 1947. (Courtesy David Kinkead, ALHC.)

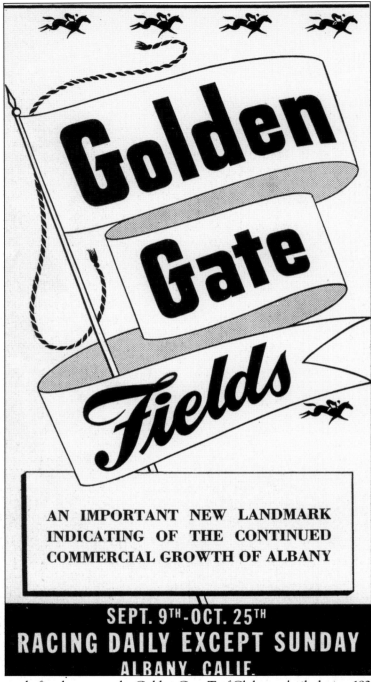

Albany's racetrack, first known as the Golden Gate Turf Club, was built during 1939 and 1940. It had barely begun to operate when, in early 1941, it was forced into bankruptcy and closed because of severe rains that turned the track into mud. This advertisement announces the reopening of the track after the war, more than six years later, on September 9, 1947. (Courtesy Golden Gate Fields, AHS.)

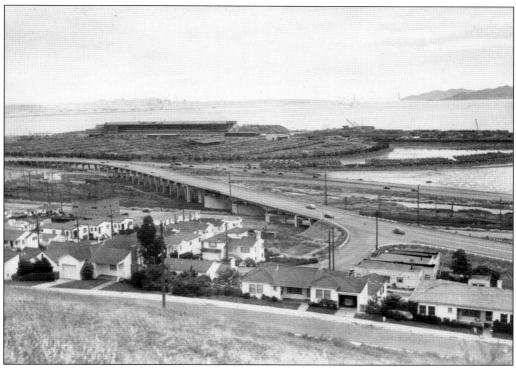

Beginning in 1942, the then-idle Golden Gate Turf Club racetrack was occupied first by the U.S. Army and then, in 1944, by the U.S. Navy. The latter established the Naval Landing Force Equipment Depot (NLFED), where an immense amount of naval landing craft used in the Pacific during World War II was repaired and stored. The above view, taken in 1944 from Albany Hill, shows the NLFED beyond the Eastshore Highway. The photograph below, taken around the same time, provides a closer look at the naval landing craft lined up near the racetrack. Point Isabel is seen in the distance. (Above courtesy Richmond Library; below courtesy Louis Stein, AHS.)

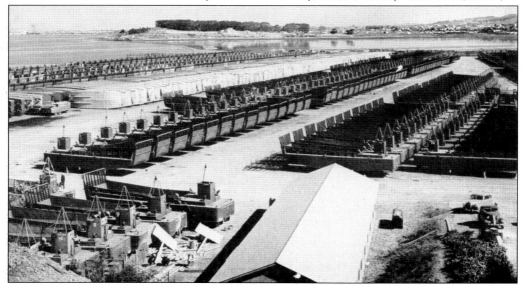

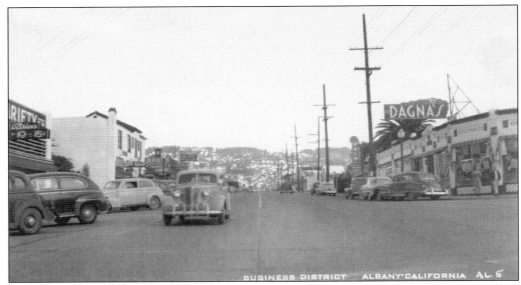

This postcard reveals part of Albany's Solano Avenue business district in the 1940s. Guiseppi "Joe" Dagna started Dagna's Market on the corner of Solano and Ramona Avenues (the current site of Long's Drugs) in the early 1930s. His son Joe Dagna Jr. took over the business in 1956, operating the store until 1971. Joe Jr. remembers the war years when there were shortages of many grocery items. His father kept a small supply of these items, such as bacon and butter, for special needs. "Someone would come in and say, 'My son is coming home on leave,' and my father would find some bacon for them." (Courtesy Ed Clausen Collection, AHS.)

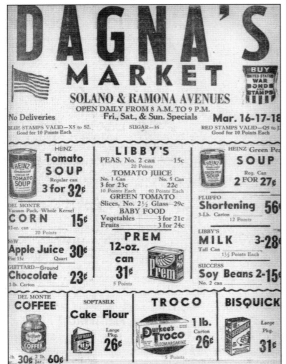

A one-pound jar of coffee cost 30¢ and a box of Bisquick just 31¢ in 1945, when this Dagna's Market advertisement appeared. Included in the promotion was the emblem encouraging customers to buy U.S. war bonds and stamps. (Courtesy AHS.)

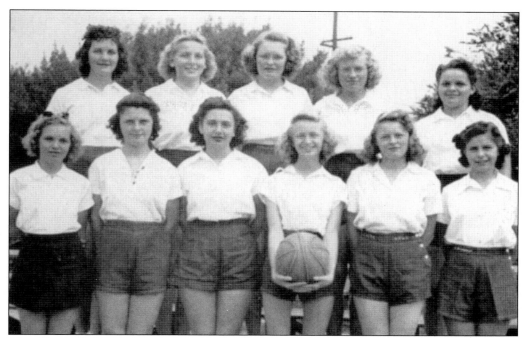

The Albany High School girls' basketball team poses in 1941. The school's yearbook for this year devoted 4 pages to girls' sports and 14 pages to boys' sports. It would still be some time before girls had opportunities in athletics similar to boys. (Courtesy Albany Unified School District, AHS.)

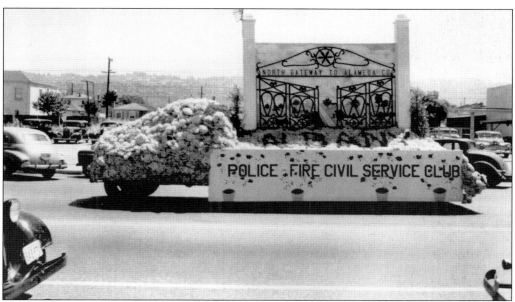

The Albany Police and Fire Departments' Civil Service Club was formed in 1946. Among the activities the club sponsored was an annual "carnival whist" card game event at Memorial Hall, which helped support a widows' and orphans' fund for department families. In 1947, the club produced Albany's first history book. This 1940s photograph shows the club's float, which includes the city motto, "Northern Gateway to Alameda County." (Courtesy AHS.)

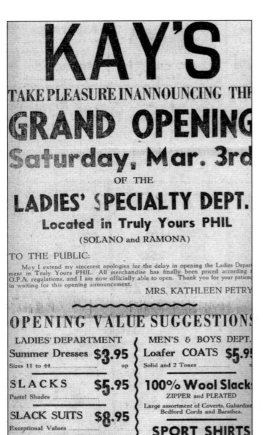

In 1945, Kay's department store on Solano Avenue advertised the opening of the Ladies Specialty Department and listed "opening value suggestions" such as summer dresses for $3.95. (Courtesy AHS.)

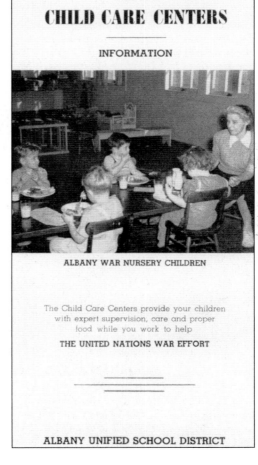

The Albany Child Care Centers, announced in this brochure, first opened in 1943 to provide child care when many mothers went to work during World War II. The centers were operated by the Albany Unified School District and supported with funds from the federal government. By 1945, eighteen teachers and 11 other employees were caring for more than 200 nursery-school and school-age children at four different centers in Albany. (Courtesy AHS.)

"Make Sure They're Sunk—Bring in Your Junk" was one World War II–era slogan encouraging participation in the many scrap drives of the time. Items collected to help the war effort included metal, rubber, paper, and even kitchen fat, the latter from which glycerin could be produced for use in explosives. Here the Albany American Legion organizes a scrap aluminum drive as patriotic citizens salute and point toward the flag in the early 1940s. (Courtesy Albany Fire Department, ALHC.)

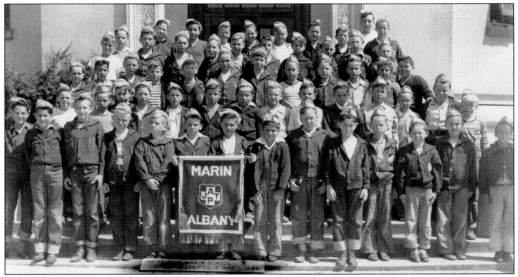

Members of the Albany Junior Traffic Police, trained by the police department to help students at crosswalks, pose on the steps of Marin School in 1946. Gordon Muir appears in the first row, fourth from left. Gordon remembers what an honor it was to be part of the traffic police. He later married Judy De Paoli, a fellow Marin student, who herself became one of the first adult traffic guards at Marin School in 1970. (Courtesy Judy and Gordon Muir, AHS.)

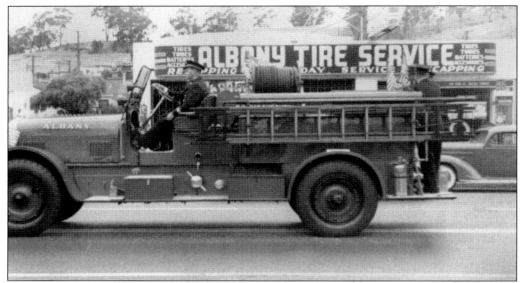

Decorated with flags for a Fourth of July parade, an Albany fire truck makes its way along San Pablo Avenue in 1948. In the background are Albany Hill and the Albany Tire Service, which first opened in 1940 and still operates at the same location today. (Courtesy Albany Fire Department, ALHC.)

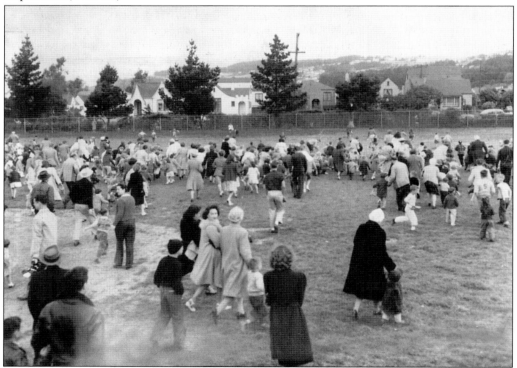

Egg hunts have been an annual spring tradition in Albany for decades. At one time, they were held in all Albany parks, as well as at University Village. This egg hunt took place at Memorial Park in 1946. (Courtesy Albany Fire Department, ALHC.)

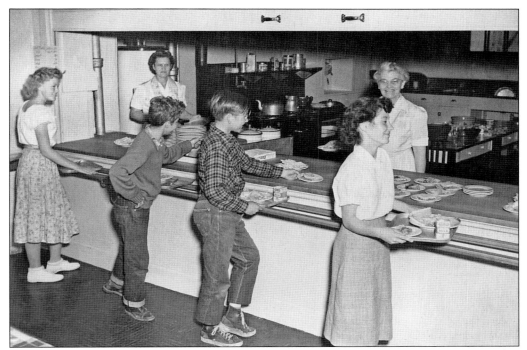

These children, lined up in the cafeteria at an Albany school in the mid-1940s, give a sense that life continued on as normal during the war. However, students would soon enter the "duck and cover" days. Filing into basements and hiding under desks was routinely practiced during air raid drills starting in the late 1940s. (Courtesy Albany Unified School District, AHS.)

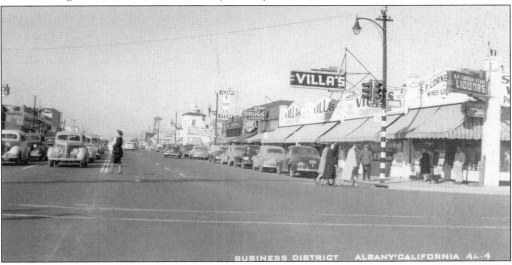

This 1940s postcard of the San Pablo and Solano Avenue intersection gives a view of Villa's Market, a grocery that operated here from the early 1930s into the 1950s. Owner Joe Villa worked as a boy in his parents' store, one of the first groceries in Albany (see page two). He expanded his business into an East Bay chain of Villa's Markets and later became the owner of the Jay Vee Liquors chain. Joe's brother Henry operated an automotive service shop in Albany, while a Joe Vila ran the J. Vila and Sons Construction Company. (Courtesy Ed Clausen Collection, AHS.)

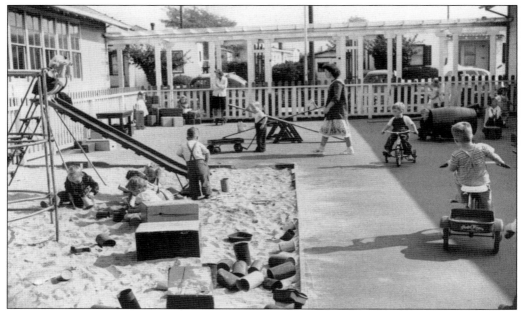

Albany Preschool was first opened in 1937 in Memorial Park by the Albany Recreation Department with funding from the WPA. Later that year, it moved to 850 Masonic Avenue, where it still operates today as a parent cooperative preschool. This c. 1948 photograph shows the north play yard. The houses in the background are those that existed along the east side of Masonic before the BART tracks were installed. The building at the left was used as a recreation center. (Courtesy Albany Preschool, AHS.)

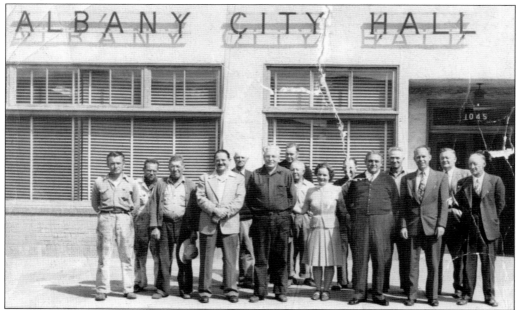

In the mid-1940s, Albany's Engineering Department poses in front of city hall, which at that time was still in its original location at 1045 Solano Avenue, just west of San Pablo Avenue. City engineer E. A. Tarr appears third from the right. (Courtesy Florence Clausen, ALHC.)

The above 1940s view of Terrace Park reveals much smaller trees than those of today and a completely different playground. Longtime residents remember when Albany parks had supervised playground programs that ran after school, on Saturdays, and during school vacations. At one time, Terrace Park also had a wading pool; the c. 1940 sign below, for the Terrace Park playground program, suggests swimming as an activity. The park remains popular with Albany families. (Above courtesy Albany Recreation and Community Services, AHS; below courtesy Albany Recreation and Community Services, ALHC.)

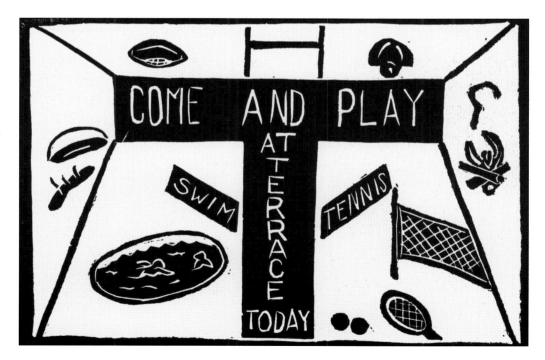

Population increases during and after World War II necessitated the opening of two new schools in Albany in the late 1940s. A 1946 bond measure provided funds to build Vista Primary School (above) at 720 Jackson Street and C. M. MacGregor Primary School (below)—named after Albany's well-known builder—at the corner of San Gabriel and Brighton Avenues. Opened in 1948, the schools at first provided facilities for primary-grade students. Over the years, they have been used for various purposes, including Albany Adult School and MacGregor High, a small alternative high school. (Above courtesy Albany Unified School District, AHS; below courtesy AHS.)

The new schools that opened in 1948 soon developed active Parent Teacher Associations. The 1949–1950 PTA officers of Vista School were, from left to right, Mrs. Frederic M. Brown, recording secretary; Mrs. John E. Ellinger, president; David M. Spellman, second vice president; Mrs. Stanley Schaugaard, first vice president; and Mrs. John Kollenbaum, treasurer. (Courtesy Albany Unified School District, AHS.)

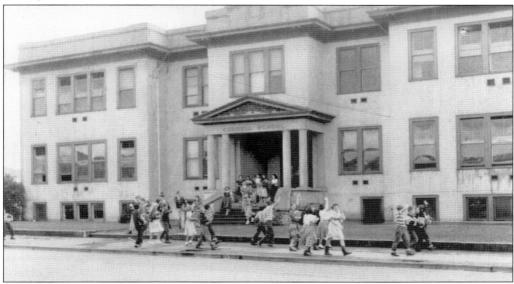

Students of the old Cornell School, first built in 1908, wave good-bye on their last day of attendance before the school was demolished in 1946–1947. Construction of a new Cornell School building along Talbot Avenue was part of the school upgrade and expansion program initiated through a successful 1946 bond measure. (Courtesy Anne Smith, ALHC.)

Welcome --

Cornell-Vista Dads Club takes pleasure in presenting to you our First Annual Sports Night.

We wish to thank our many friends for their interest and cooperation, and the many friendly merchants whose "Ads" appear in this program.

It is the aim of the "Dads Clubs" to work toward the betterment of ALL children, and the proceeds of this show will be used for Child Welfare.

Speaking for myself and all of the members of the Cornell-Vista Dads Club.

Thank You

Lou Coggiola - Pres.

OUR SHOW PRESENTED BY
AL LIOTTA —— MASTER OF CEREMONIES

A Plea --- Invest In Youth

To All Persons Interested in:

Providing adequate schoolhousing facilities for all Albany children,

Protecting property values,

Providing a real Athletic Field for Albany,

"VOTE YES"

School Bond Election, Tuesday - Oct. 11, 1949

Cornell-Vista Dads Club

Dads' Clubs, popular in Albany at this time, were among the groups that helped raise funds to support Albany schools. Seen here is a portion of the program for the First Annual Sports Show, organized by the Cornell-Vista Dads' Club in 1949. Held at the Albany High School Gymnasium, the show featured demonstrations of different sports. (Courtesy AHS.)

Six

THE 1950s

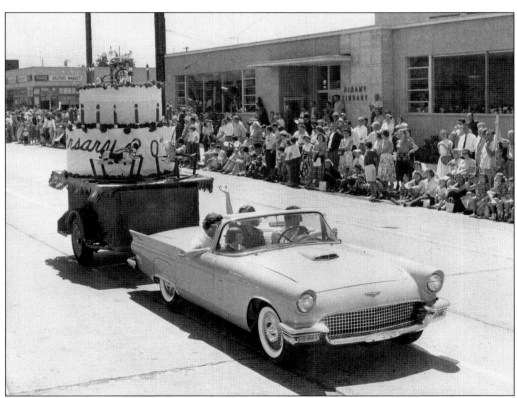

In 1957, the Fourth of July parade was a well-attended event, judging by the crowds lining the sidewalk. Albany Preschool's 20th anniversary float makes its way west on Solano Avenue past the Albany Library. In 1952, the library moved from its former site above city hall at 1045 Solano Avenue to this new location at Talbot and Solano Avenues. (Courtesy Albany Preschool, AHS.)

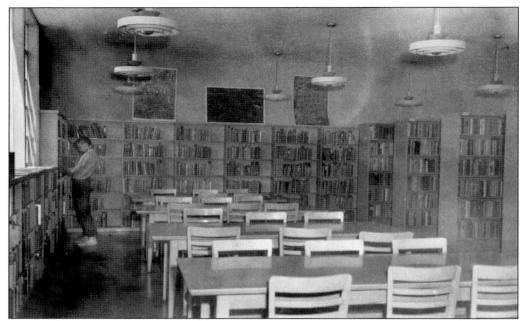

Neatly aligned tables and chairs were part of the reading room at the new Albany Library. The library is pictured shortly after its 1952 opening at Talbot and Solano Avenues. (Courtesy ALHC.)

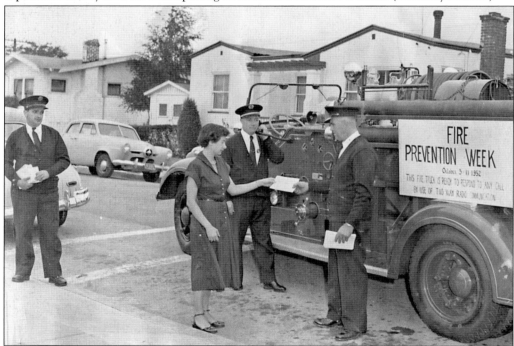

Albany firemen made neighborhood visits during Fire Prevention Week in October 1952. The sign on the truck boasts, "This fire truck is ready to respond to any call by use of two way radio communication." Shown here from left to right are D. De Giglio, Mrs. Helmut Loring, Capt. J. Vercelli, and H. Johansen. (Courtesy Albany Fire Department, ALHC.)

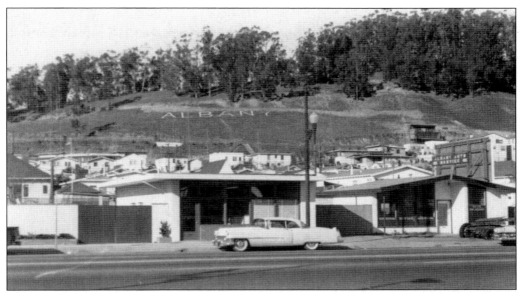

In the early 1950s, there was still enough open space on the east side of Albany Hill for the city name to appear there in large letters. The name was a common sight during this time for those traveling on San Pablo Avenue, seen in the foreground. (Courtesy AHS.)

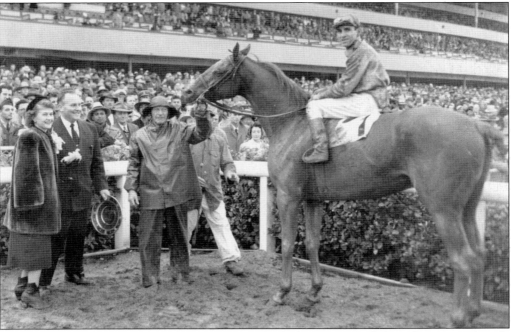

Albany mayor Jerome Blank and his wife, Muriel Blank, pose at far left in the winners' circle at Golden Gate Fields in 1952. The jockey is the famous Willie Shoemaker. Jerome Blank, who grew up in Albany, served on the city council for many years and operated an Albany real estate business for decades. Eventually, he became known as "Mr. Albany." An antique street clock was installed in his honor on Solano Avenue near Kains Avenue before his death in 2001. (Courtesy Deborah Blank, ALHC.)

Albany May Lop Hill for Home Sites

By JACK RASMUSSEN

Plans for a multi-million-dollar project that would chop Albany's hill landmark down to a gently rolling plain on which a fashionable "Nob Hill" district would be built

were revealed today by C. H. Eccleston, Albany, Berkeley and Walnut Creek realtor and developer.

The mammoth undertaking as outlined by Eccleston would involve:

1. Trimming more than 200 feet off of the 345-foot peak.

2. Subdividing the land for the construction of 300 homes.

3. Creation of the Albany Improvement Assn., a corporation made up and controlled by citizens and businessmen of Albany to carry out the vast project.

Total cost of the operation would be close to $7,000,000, Eccleston said.

YEAR-LONG STUDY

The tree-studded hill, which juts up sharply from the western section of Albany between San Pablo Ave. and East Shore Highway, has been the object of an ambitious study by the local developer and engineers for more than a year.

Several other attempts to tamper with the landmark in past years have met with failure.

In disclosing the new plan, Eccleston said, "for the first time we have a composite map in which the grades of the hill will be under 10 per cent and the entire hill would be ideally developed . . . If it were left to the individuals (the separate land owners) it would be a conglomeration of misfitted streets and grades."

As to the failure of other developers, he said, "I have found

Dotted white line in picture above shows approximately what new contour of Albany Hill would be if proposed multi-million dollar development project wins approval of Albany City Council and Planning Commission. Composite photograph below illustrates probable resulting change in Albany skyline. Mammoth undertaking, which would involve removal cubic yards of earth, is proposed by C. H. Eccleston. Pictures were taken Filter Plant on Berkeley Park Blvd. western side of hill. —Gazette

Albany Hill, a major East Bay landmark, has a long history of controversial development proposals, several of which would have removed a large portion of the hill itself. A 1953 *Berkeley Gazette* article described one multimillion-dollar proposal to trim the top 200 feet off of the 340-foot hill to build a "Nob Hill"–style development with 300 homes. The photographs show before and after views of the hill. Like other suggested developments, this proposal met strong local opposition and did not get far. Several other proposals would be made after this, eventually resulting in the construction of a condominium complex on the west side of the hill. (Courtesy AHS.)

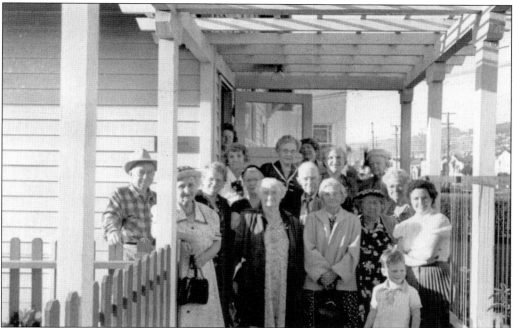

Above, members of the newly formed Albany Senior Citizens Club gather in front of the Recreation Center at 850 Masonic Avenue, their first meeting place, in 1954. The group began with the help of Soroptimists International of Albany and the Albany Recreation Department. In 1962, a new Senior Center was constructed at the site using a combination of local donations and state funds and has since been remodeled into an expanded building that still houses the center today. Below, a group meets on Masonic Avenue in 1954 for one of the seniors' first outings. (Both courtesy Albany Senior Center, AHS.)

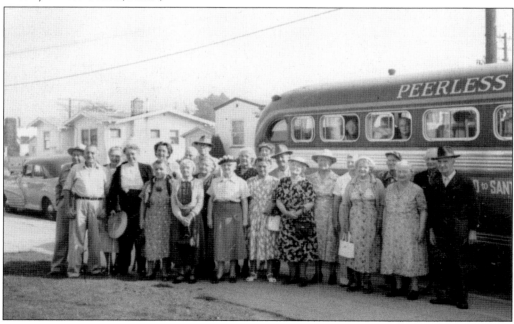

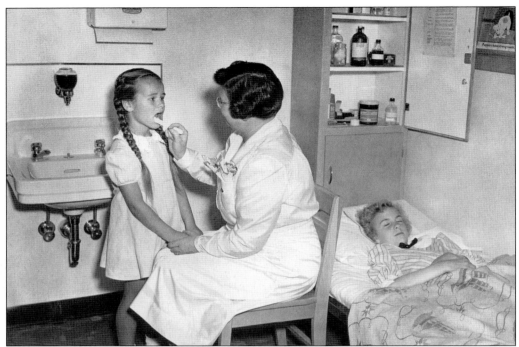

Nurses were still regularly employed at Albany schools until the mid-1980s. The Vista School nurse is seen here around 1950. (Courtesy Albany Unified School District, AHS.)

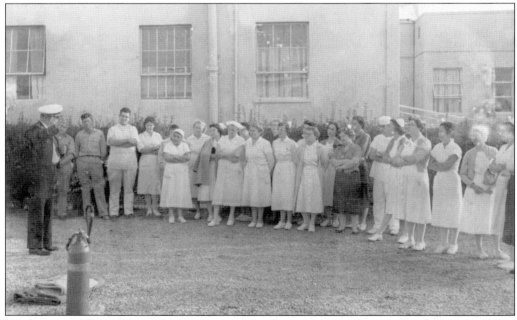

Employees at Albany Hospital receive instruction from a fireman during a fire drill in the 1950s. Originally known as Humboldt Hospital, the building would later become Alta Bates Hospital at Albany. It was razed in the early 1990s to make way for the new Albany Library and Community Center on Marin Avenue. (Courtesy Albany Fire Department, ALHC.)

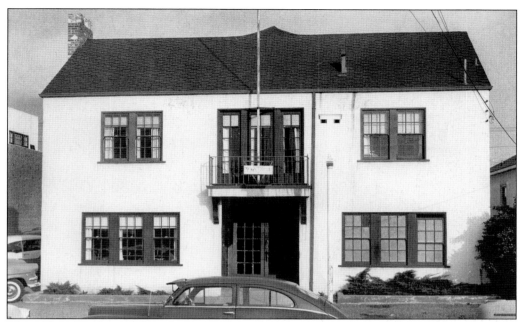

The Albany YMCA was first organized in 1921 but was not given a permanent home until 1930, when the above building was constructed at 921 Kains Avenue. Seen here in the 1950s, the structure was expanded and remodeled over the years and is still used today. During World War II, the YMCA operated as a USO Center, where a Junior Hostess Committee organized dances and activities for servicemen stationed nearby. Below, longtime Albany YMCA executive secretary Elmer Coble presides over a basketball awards ceremony in 1952. Among the many other activities offered during this time period were tumbling, boxing, and "posture and corrective exercises" for children; a married couples' badminton group; and Hi-Y clubs for teenagers. (Above courtesy Albany YMCA, AHS; below courtesy ALHC.)

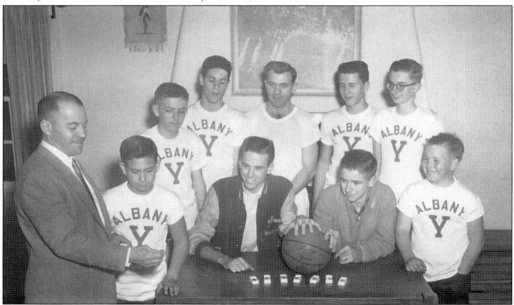

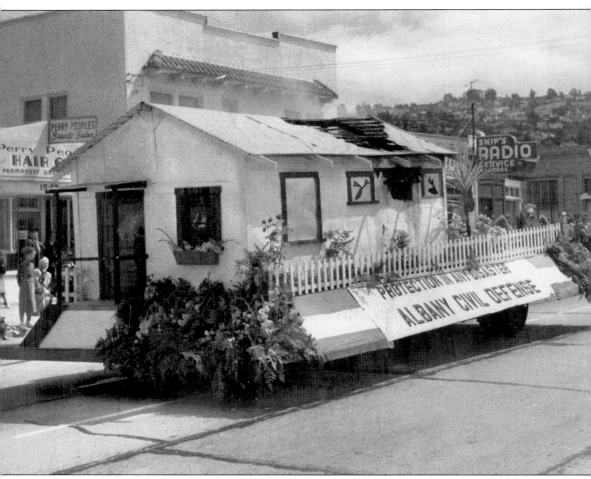

Civil defense, a reaction to the cold war, was a dominant theme throughout the 1950s. Albany had an active civil defense program, described in the following quote from a 1950s news article: "Candidate for making the most progress in civilian defense: Albany. . . . While some cities are still shifting gears, Albany is really rollin' along in high. . . . Nearly every person in the city is registered for emergency duty. Block wardens have been sworn in. Drills for volunteer firemen have started. And schooling for auxiliary policemen gets started very soon." Here Albany's civil defense program float for a 1950s Fourth of July parade passes by spectators gathered along the 1500 block of Solano Avenue. The float featured helmeted volunteer workers battling to save a bomb-damaged house. (Courtesy Albany Fire Department, ALHC.)

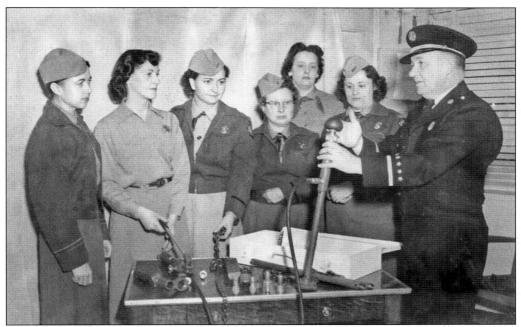

Albany's civil defense program was headed by assistant fire chief Gerald Browne. Above, he trains a group of auxiliary policewomen to operate emergency communication equipment. Many other groups, including Scout troops, housewives, and senior citizens took civil defense training classes at this time. Below, members of the police, fire, and auxiliary police departments participate in a 1956 drill at Albany's Control Center, set up to coordinate disaster evacuation and relief. The map on the wall likely depicts the designated Disaster Evacuation Routes of the time. (Both courtesy Albany Fire Department, ALHC.)

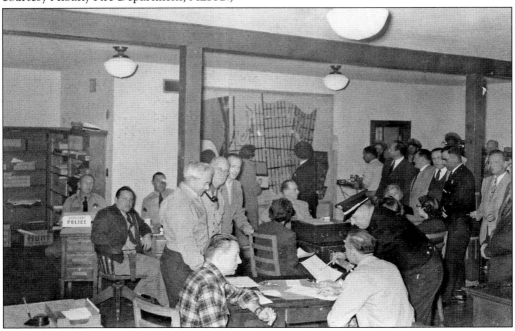

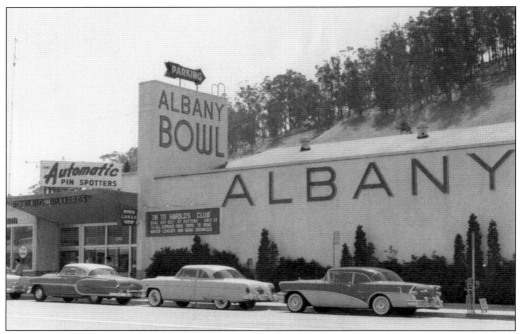

Albany Bowl opened at 540 San Pablo Avenue in 1949. Seen here in the early 1950s, the business, which still operates today, was started by Frank Lacy, who, along with his son John Lacy, ran the bowling alley for 36 years. (Courtesy Albany Bowl, AHS.)

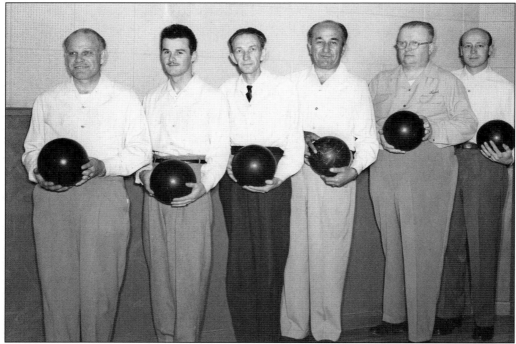

An Albany Bowl team lines up for a photograph in the early 1950s. Albany Bowl owner Frank Lacy appears second from the right. (Courtesy Albany Bowl, AHS.)

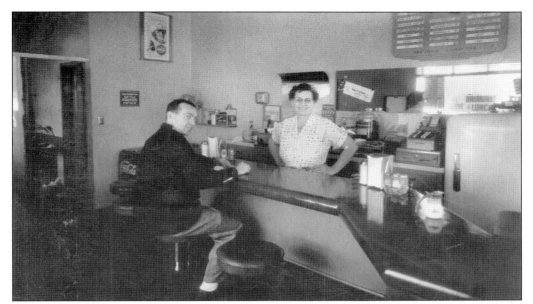

During the mid-1950s, customers could drop into Flo's, a small restaurant on the corner of Solano and Masonic Avenues where Flo Allen served up breakfast and lunch. The menu featured a 25¢ plate of hotcakes, 50¢ Min-It-Steak sandwiches, and 75¢ bacon and eggs. A cup of coffee cost just a dime. Pictured at the counter with Flo is Kayo Denham. (Courtesy Kayo Denham, AHS.)

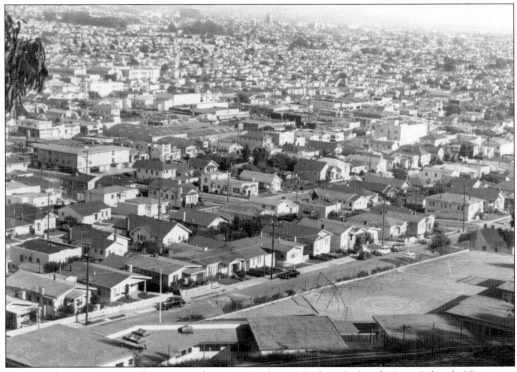

This southeast view of Albany was photographed in 1953 from behind Vista School. (Courtesy Albany Unified School District, AHS.)

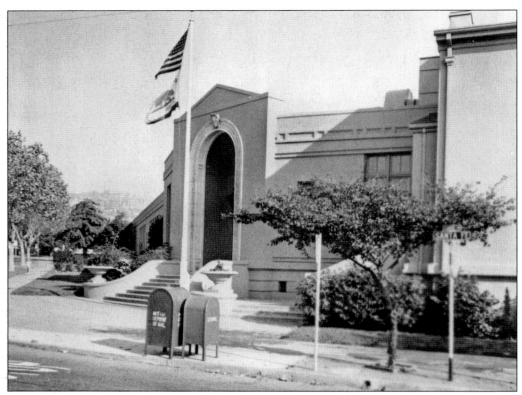

Marin Elementary School, built in 1917, became known to some as the "Pink Palace" because of its mauve coloring. This 1957 photograph shows the school's entrance at the corner of Santa Fe and Marin Avenues. (Courtesy Albany Unified School District, ALHC.)

The old Marin School playground, seen here about 1950, ran along the east side of the school building, facing Curtis Street. (Courtesy Albany Unified School District, ALHC.)

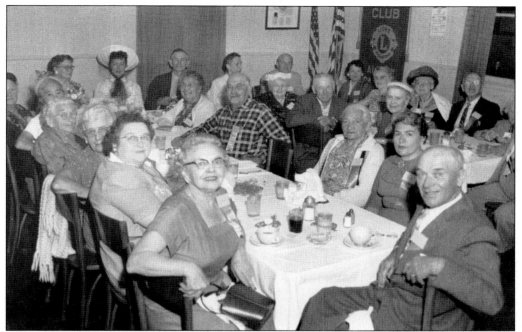

Albany's golden anniversary dinner, held in accommodations provided by the Albany Lions Club, was attended by many early Albany residents and pioneers. Appearing in this 1958 photograph are members of the Higuera, Dorenzo, Murison, Fleming, Wemple Parker, Steiglitz, Krieder, Roberts, Coggiola, Frey, Woodbury, Jacobi, Ellis-Olson, Walkup, and Hageman families. The Albany Lions Club has existed for more than 60 years. (Courtesy ALHC.)

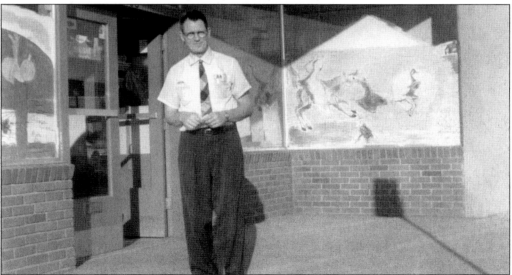

Harold "Hal" Denham stands in front of his Denham's Department Store at its second location, 1185 Solano Avenue, around 1956. Denham was an active member of many community groups, especially the Albany Chamber of Commerce, where he served as president and manager, working on various committees. In the 1950s, he also served as president of the nonprofit Albany Senior Center Foundation. (Courtesy Kayo Denham, AHS.)

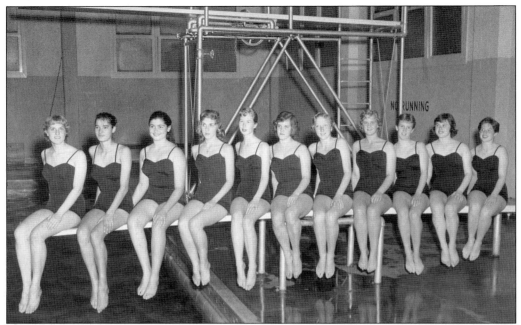

The Albany Pool, built with the assistance of voter-approved bond measures, opened in 1950. Above, a women's swim team poses at the pool in 1952. At this time, free swim lessons were given to all elementary and high school students. Owned and operated since its inception by the Albany Unified School District, the pool still operates at its same Portland Avenue location. Below, Peggy Mc Quaid, who would grow up to be a longtime director of the pool, plays in a pile of leaves in the mid-1950s in front of the Marin Avenue home where she continues to live today. (Above courtesy ALHC; below courtesy Peggy Mc Quaid, AHS.)

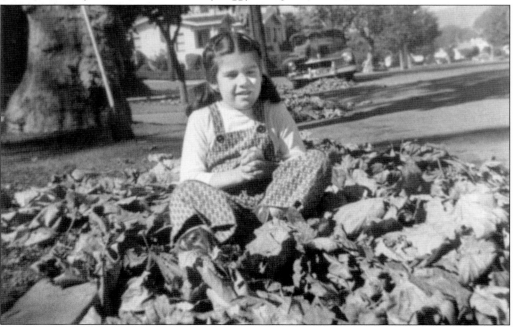

Girl Scouts pose with Albany assistant fire chief Gerald Browne after completing a 1959 civil defense training course. (Courtesy Albany Fire Department, ALHC.)

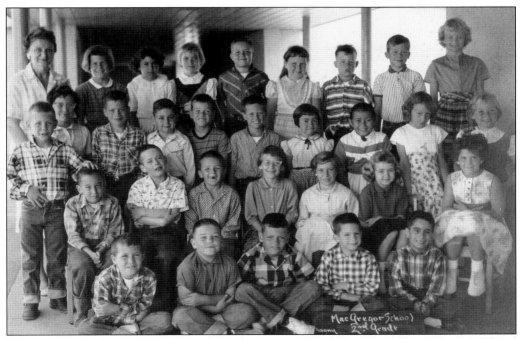

A second-grade class at MacGregor School poses in 1959. (Courtesy Albany Unified School District, AHS.)

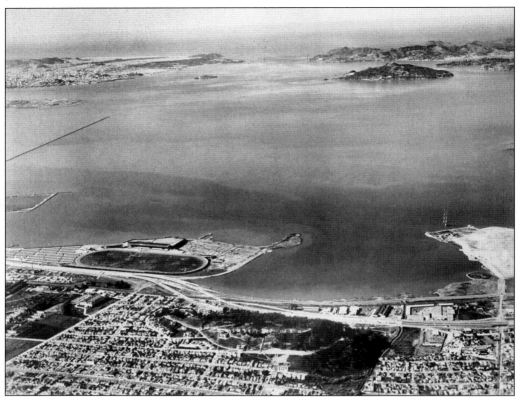

In this aerial view of Albany from the late 1950s or early 1960s, much of Albany Hill remains undeveloped, and the area at the foot of the Buchanan Street Extension—where dumping occurred for many years—is just starting to fill in the bay. (Courtesy City of Albany, ALHC.)

The Ivy Room, Discounts Unlimited, and Albany Drugs are among the businesses visible in this late-1950s or early-1960s view of San Pablo Avenue just north of Solano Avenue. (Courtesy Albany Fire Department, ALHC.)

Seven

THE 1960s

Citizens watch and a band plays while the flags are lowered for the last time at Albany's old city hall. The event was part of a 1966 celebration marking the opening of the new civic center at the corner of Marin and San Pablo Avenues. Next to city hall is Tom's Shoe Shop, where Tom Muzinich repaired shoes for many years. Tom, who attended Cornell School and Albany High School, acquired the business in the 1950s from his father, who had first worked with cobbler Carlo Carlevaro (father of Mary [Carlevaro] Neylon). The Muziniches emigrated from Yugoslavia, where generations of their family had worked as cobblers. (Courtesy ALHC.)

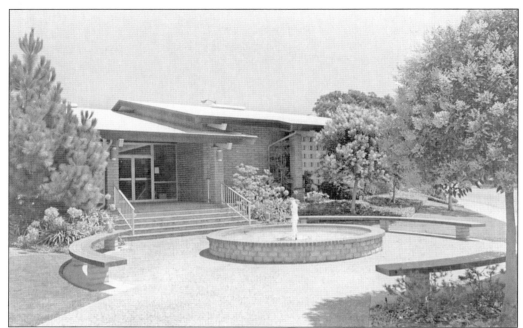

Albany's new city hall was built at the corner of Marin and San Pablo Avenues. The land, part of the Gill Tract, was purchased from the University of California. The entrance to the building is pictured shortly after it opened in 1966. (Courtesy Albany Fire Department, ALHC.)

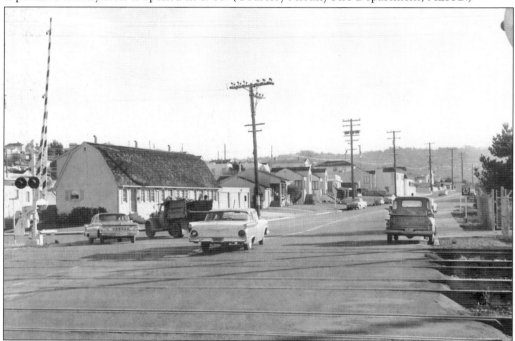

In 1960, cars near the west end of Buchanan Street still had to drive over the Southern Pacific Railroad tracks. Later the Buchanan Street Overpass would carry cars over the tracks and connect with the freeway. (Courtesy ALHC.)

Around the same time that Albany's new civic center was built in the mid-1960s, the Marin Avenue Extension was also constructed. The extension began at the Marin and San Pablo Avenue intersection, crossed a portion of the Gill Tract, and then connected with Buchanan Street. This view of the southwest corner of San Pablo and Marin Avenues, at the east end of the extension, was captured in 1965. (Courtesy ALHC.)

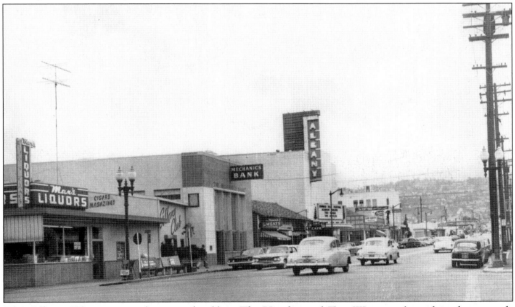

The Albany Theatre was showing the films *The Hustler* and *Two Women* when this photograph of the San Pablo and Solano Avenue intersection was taken in 1961. Max's Liquors (originally owned by Max Etingoff and still open today) had by now replaced the S. P. Corner Store, which had operated at this corner for many years starting in 1923. Mechanics Bank, a longtime East Bay financial institution, has had various locations in Albany over the years. (Courtesy Albany Fire Department, AHS.)

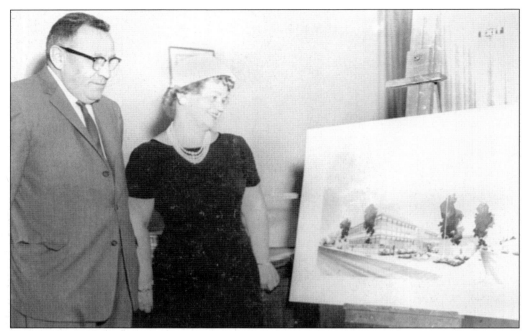

Kathie Zahn, Albany's first woman mayor, was also one of the city's most controversial politicians. A member of the city council during the 1950s, Zahn had an outspoken style that frequently generated news headlines. She was elected mayor in 1960 but was recalled the next year. With Lewis Howell, Zahn looks over a proposal for a new city hall on Solano Avenue about 1960. (Courtesy Albany Fire Department, ALHC.)

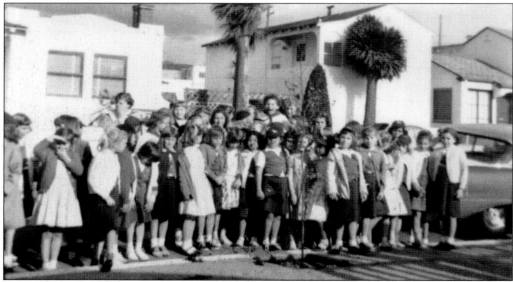

The Albany Camp Fire Girls commemorated the 50th anniversary of their nationwide organization by presenting a tree to the City of Albany in March 1961. The tree was planted in front of Albany Preschool on Masonic Avenue. In the background of this view are houses that would be demolished or moved a few years later to make way for the BART tracks. (Courtesy Deborah Blank, ALHC.)

Pat Nixon visited Albany in 1962, when Richard Nixon was running for governor of California. She is pictured here (next to the lamp) at the Ramona Avenue home of Muriel and Jerome Blank (second from the right). (Courtesy Deborah Blank, ALHC.)

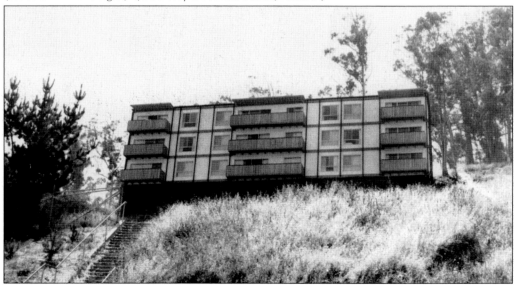

In 1962, this apartment building was one of the first of its kind on Taft Street. It would be followed over the years by several nearby condominium developments on the east side of Albany Hill. (Courtesy Deborah Blank, ALHC.)

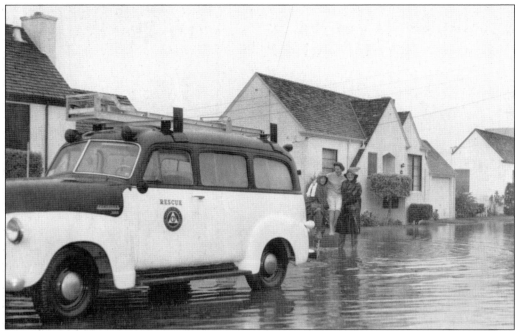

A resident from the neighborhood of Dartmouth Street and Key Route Boulevard is rescued during an October 1962 flood. (Courtesy Albany Fire Department, ALHC.)

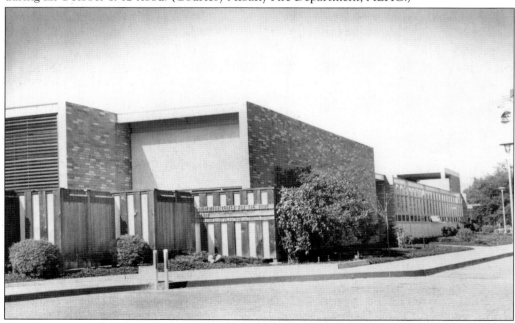

The Orientation Center for the Blind relocated from Oakland to 400 Adams Street, Albany, in 1964. Operated by the California Department of Rehabilitation, the residential center continues to offer services for blind and visually impaired individuals. Training at the center averages seven months and includes classes in daily living skills, Braille, vocational skills readiness, independent travel, and attitudes about blindness, among others. (Courtesy Dorothy Larimer Boyd, AHS.)

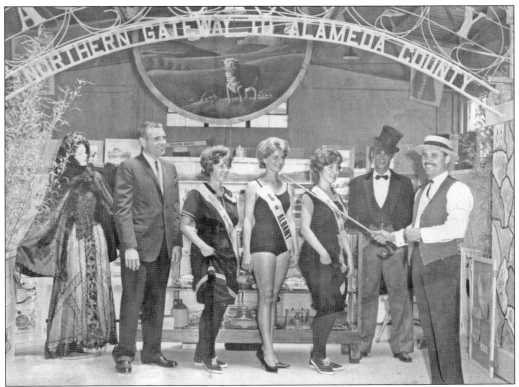

The City of Albany booth at the 1962 Alameda County Fair featured a combination of modern and historical themes. Appearing beneath an archway displaying the city name and motto are, from left to right, Mayor Joel Parker; JoAnn Keck (Connor), who later served as Albany city treasurer; Lorrene Baum, the 1962 Maid of Albany; Carol Keck (Meyer); and an unidentified master of ceremonies. (Courtesy Albany Fire Department, ALHC.)

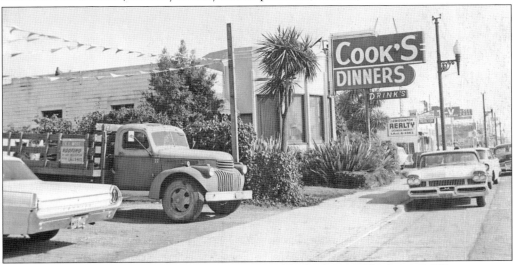

This early-1960s view shows the east side of the 1000 block of San Pablo Avenue. What was once Cook's Dinners is now a Thai restaurant. (Courtesy Albany Fire Department, ALHC.)

Catherine Webb, pictured at her home in the 1960s, lived in Albany for more than 50 years and participated in the community in many ways. An Albany Hill activist for many years, she helped start the *Albany Community News* in the 1970s and founded the first Albany Historical Society. Webb, who authored the history book *Stories of Albany*, donated her collection of historical photographs to the Albany Library in 1994. She died in 1997. (Courtesy ALHC.)

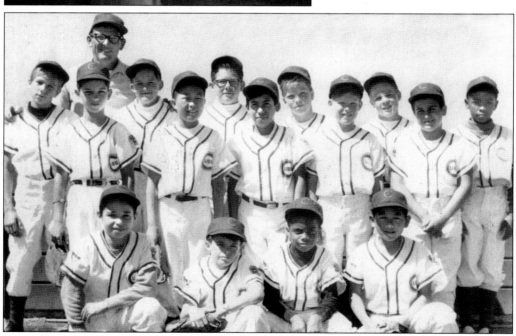

The Albany Cubs Little League team poses for a photograph with coach Bob Luoma in 1965. The league began in 1956 with four teams for boys ages 10 to 12. Today it has approximately 30 teams for boys and girls ages 7 to 18, attracting players from North Berkeley and Kensington as well. (Courtesy Fern Luoma, AHS.)

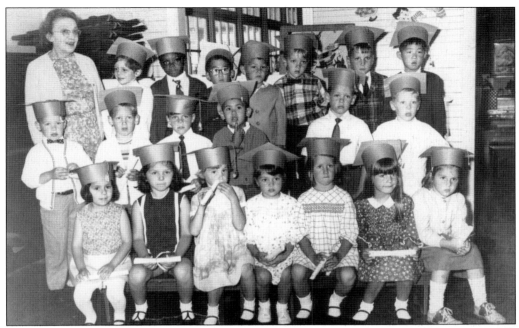

The graduating class at Albany Preschool is pictured with longtime director Nell Curran in 1967. Curran joined the preschool in 1939 as the assistant to the first director, Eleanor Quiggle. She then became director herself in 1941, holding the position until her retirement 30 years later. (Courtesy Fern Luoma and Albany Preschool, AHS.)

Program

SEPTEMBER 7, 1967 – 12:00 to 1:00 p.m. Cafeteria – WELCOME LUNCHEON FOR TEACHERS.

SEPTEMBER 11, 1967 – WELCOME HOUR Teacher's Lunch Room – 8:45 to 9:45 a.m. and 12:30 to 1:30 p.m.

SEPTEMBER 21, 1967 – 1:30 p.m. – Cafeteria. Panel discusses: "ALBANY SCHOOLS' APPROACH TO NEW HEALTH PROGRAM – SEX EDUCATION FOR KINDERGARTENERS?

OCTOBER 10, 11 & 12, 1967 – 2:00 p.m. Cafeteria – ROOM TEAS.

OCTOBER 31, 1967 – 1:00 p.m. – School Playground – HALLOWEEN PARADE.

NOVEMBER 2, 1967 – 7:30 p.m. – Auditorium Further discussion by panel on ALBANY SCHOOLS' NEW HEALTH PROGRAM.

FEBRUARY 1, 1968 – 7:30 p.m. – Cornell Auditorium. FOUNDERS DAY. All five Albany School PTA's in a combined program celebrating the founding of PTA.

FEBRUARY 12, 1968 – LINCOLN'S BIRTHDAY HOLIDAY.

FEBRUARY 17, 1968 – Cornell School PTA sponsors RUMMAGE SALE.

FEBRUARY 22, 1968 – WASHINGTON'S BIRTHDAY HOLIDAY.

MARCH 7, 1968 – 7:30 p.m. – Cafeteria An informal discussion of the NARCOTICS PROBLEM with Insp. E.A. Skeels of the Berkeley Police Department.

APRIL 4, 1968 – 1:30 p.m. – Cafeteria "ROOM MOTHERS' APPRECIATION DAY." Flower arrangements by Mrs. V. Martinson.

APRIL 8 through APRIL 14, 1968 – EASTER VACATION.

This PTA schedule, published for the 1967–1968 school year, lists dates for a meeting about a new district-wide health program, a PTA Founders' Day celebration, and an "informal discussion of the narcotics problem." (Courtesy AHS.)

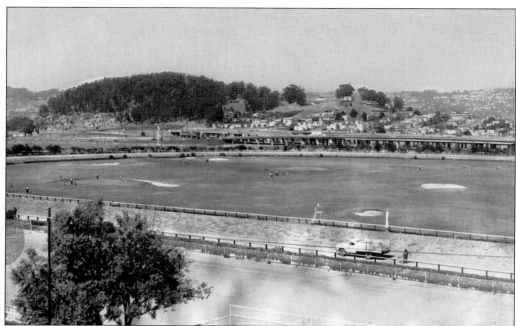

The above early-1960s photograph shows a northeast view of the Golden Gate Fields racetrack and golf course. The same area was once tideland and part of the bay (compare to page 30). Dirt from the top of Fleming's Point was used to fill in the bay in 1940 to make space for the racetrack. The highway overpass is located near what was once the water's edge. Below, a close-up view of racing also reveals the undeveloped west side of Albany Hill. (Above courtesy Albany Fire Department, ALHC; below courtesy Golden Gate Fields, AHS.)

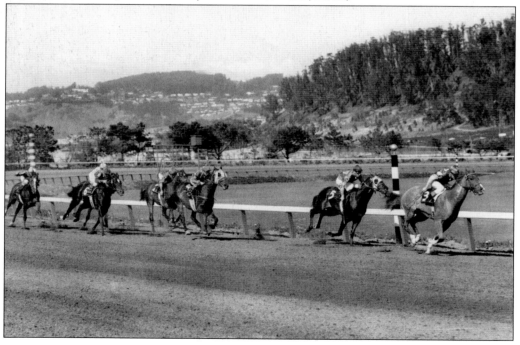

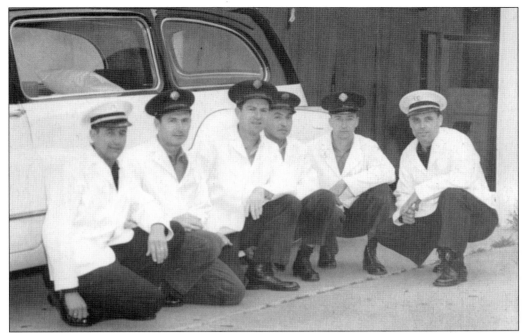

Members of the Albany Fire Department's "white coat–inhalator" rescue squad appear here in 1963. The team, which carried an oxygen tank (or "inhalator"), functioned as the 1960s equivalent of today's paramedics. Seen here from left to right are Bill Lanctot, Gerald Vittitow, Frank Heaney, Nestor Mestas, Ken Cochran, and Raul Miranda. (Courtesy Albany Fire Department, ALHC.)

A group of Albany city officials and citizens plants curbside trees in 1969. Pictured from left to right are Tony Gianelli, Joe Carlevaro, Marie Gianelli, Bud Rooney, Charles Graeber, and Tony Kalberer. (Courtesy Albany Park and Recreation Department, ALHC.)

Dario Meniketti (center), a dedicated Albany activist and volunteer for decades, has just received one of his many awards at this gathering in 1965. Meniketti's daughter Nancy (left) and Lynn Doxtader stand with him. In 2006, Albany Community Foundation volunteers constructed the Dario Meniketti Memorial Public Information Kiosk at the corner of Solano Avenue and Curtis Street. (Courtesy Ruth Meniketti, AHS.)

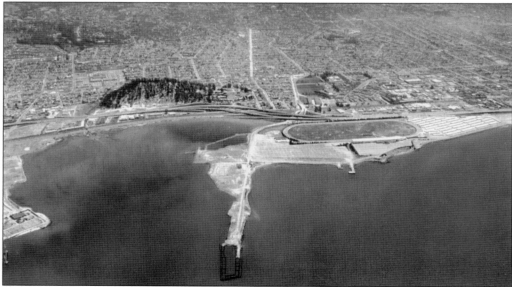

This mid-to-late-1960s aerial photograph of Albany's waterfront shows the landfill operation at the foot of the Buchanan Street Extension, which began in the early 1960s and continued into the early 1980s. The area would later become known as "the Bulb." Like Albany Hill, the waterfront area has been the center of numerous divisive development proposals over the years. The nature of its future continues to be controversial today. (Courtesy City of Albany, ALHC.)

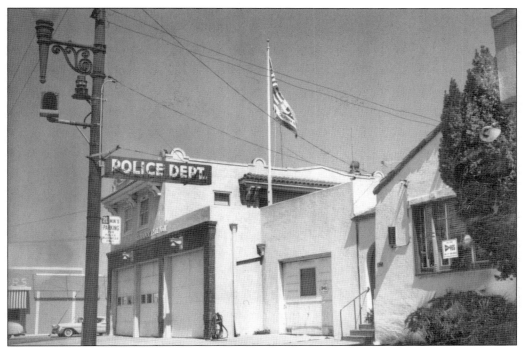

In 1965, the Albany Police Department was still housed in converted bungalows on San Pablo Avenue near Washington Street. Next door, the fire department had by this time expanded its building to accommodate more trucks. (Courtesy Albany Fire Department, ALHC.)

Police department employees pose at the new civic center in 1968. (Courtesy Dorothy Larimer Boyd, ALHC.)

John Pleich (far right), president of the Albany–El Cerrito Exchange Club, presents youth awards in the 1960s. Pleich was for many years the owner of Flowerland Nursery, which is still in business on Solano Avenue. At one time, he grew plants for the nursery in an undeveloped area of the Terrace Park neighborhood, now Tevlin Street. (Courtesy Dorothy Larimer Boyd, ALHC.)

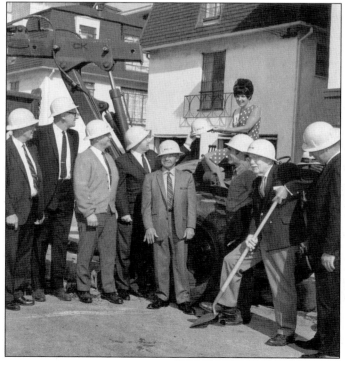

Susan Rotramel, Maid of Albany for 1969, sits atop a Pacific Gas and Electric Company backhoe to help publicize the installation of underground utilities on Solano Avenue. Pictured with her are, from left to right, chamber of commerce manager Hal Denham; PG&E engineer J. J. Sturgeon; Joe Dagna, cochairman of the Solano Avenue Lighting and Beautification Committee; Vice Mayor Hubert "Red" Call; chamber of commerce president Elmer Coble; city councilman Joe Carlevaro; William Garren, cochairman of the Lighting and Beautification Committee; and Albany administrative officer James Turner. (Courtesy Albany Chamber of Commerce, AHS.)

Eight

THE 1970S

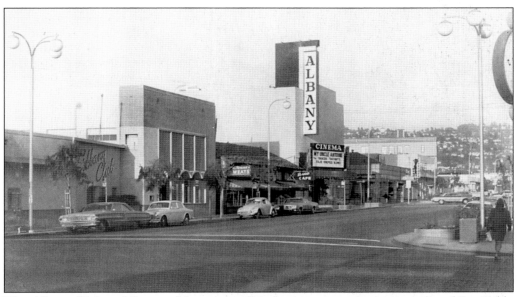

The Albany Club and Famous Meats are still in business near the intersection of San Pablo and Solano Avenues in 1971 (compare to page 99). The film *My Uncle Antoine* is playing with Francois Truffaut's *Four Hundred Blows* at the Albany Theatre. (Courtesy Albany Fire Department, ALHC.)

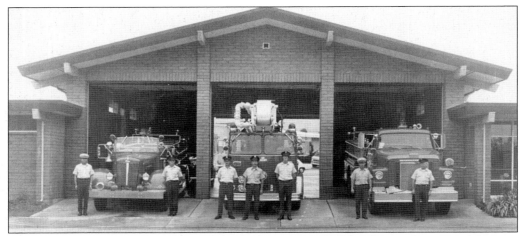

Albany firefighters appear in front of the firehouse in 1972. The department moved from its longtime home at Washington and San Pablo Avenues to this site along Marin Avenue after the adjacent civic center opened in 1966. (Courtesy Albany Fire Department, ALHC.)

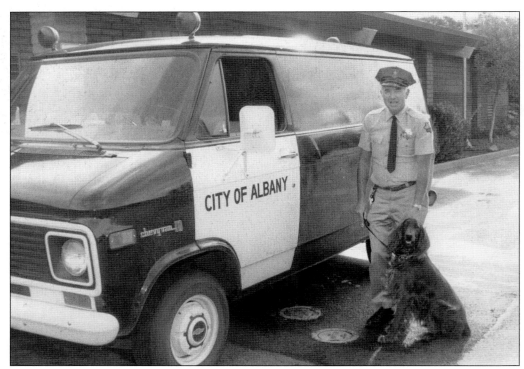

Albany's animal control officer, John Sawers, stands next to a City of Albany van in the 1970s. Known for his friendliness, Sawers returned wandering dogs to their owners. (Courtesy Albany Fire Department, ALHC.)

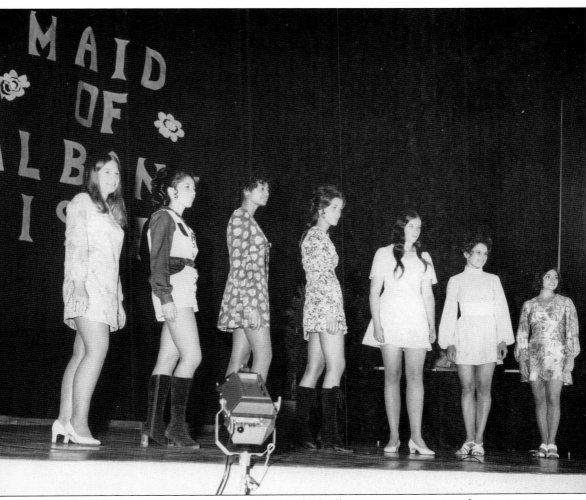

In the 1970s, young women compete in the Maid of Albany contest, an annual competition sponsored by the Albany Chamber of Commerce from approximately the 1950s to the 1980s. Winners helped promote various city events during their reign as maid. At this time, they also received a cash prize and a trip to Disneyland, and they competed in the Maid of Alameda County pageant, the winner of which went on to try for the Maid of California title. (Courtesy Albany Chamber of Commerce, AHS.)

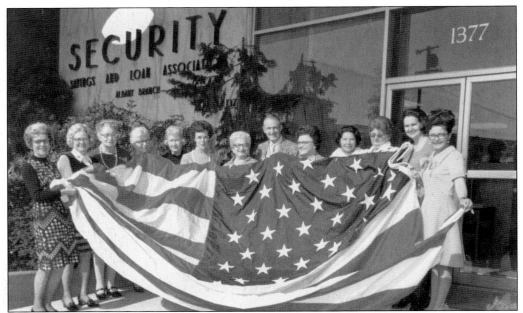

In 1973, members of the Soroptimists International of Albany display one of the large flag they purchased for the community. These flags once flew over the Buchanan Street Overpass. (Courtesy Fern Luoma, AHS.)

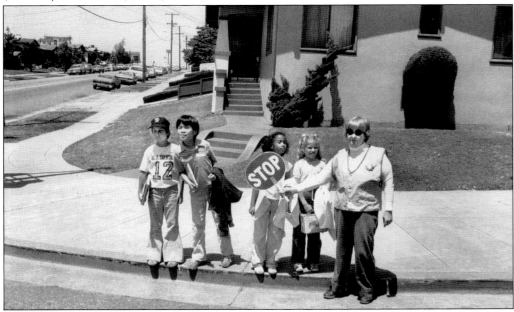

Bea Besette became one of Albany's first adult crossing guards in 1973, the year this photograph of her (with unidentified students) was taken at the northeast corner of Marin and Santa Fe Avenues. She has worked the same intersection ever since, as have other longtime guards, including Judy Muir, Esther Patterson, and the late Ethel Hansen, in whose memory a bench was installed near Cornell School. Adult guards replaced the Junior Traffic Patrol about 1970. (Courtesy Frank and Bea Besette, AHS.)

CHIN WILL WORK FOR:

● **GREATER COMMUNITY PARTICIPATION**

The schools alone cannot solve our problems. It takes the co-operation and dedication of students, teachers, administrators, parents, and community leaders.

Bob Chin, pictured in this 1970 school board campaign pamphlet, recalls that when he first moved to Albany in 1956, it was difficult for Asians and other minorities to purchase homes. "We looked at a house on Ordway, but we were told the neighbors objected," said his wife, Bess. The couple finally bought a house in the Albany Terrace neighborhood, through the help of friends who already lived there. In 1970, Bob Chin successfully ran for the Albany School Board and was reelected in 1974, serving a total of eight years. He participated in a reorganization of Albany schools in the mid-1970s. (Courtesy Bob Chin, AHS.)

Above, the Albany High School wrestling team competes in a meet held in the old high school's auditorium-gymnasium during the 1970s. Many people recall attending various events in the gym—from high school sporting events to community meetings—sitting in the wooden chairs in the raised seating area. Below, an exterior view of the gymnasium shows the architectural style that was popular when the building was constructed in the early 1940s. The gym was torn down in 1998, along with other portions of the old high school, to allow for a new, up-to-code structure. (Above courtesy Albany Unified School District, AHS; below courtesy Peggy Mc Quaid, AHS.)

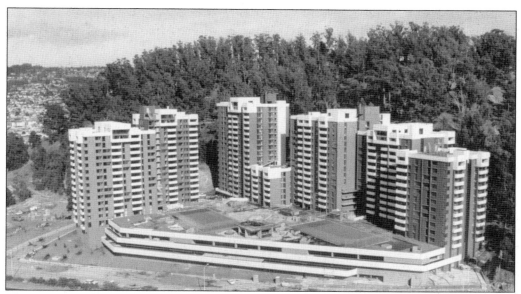

The Gateview condominium complex was built on the west side of Albany Hill in the mid-1970s. Seen here shortly after completion, the seven high-rise towers constitute the first phase of the development. Originally, 2,500 units were proposed for the entire complex, but plans were scaled down. Several smaller condominium units were added along Pierce Street in the mid- to late 1980s. (Courtesy AHS.)

In the late 1970s or early 1980s, Mary Hartung (center) and Bill Hartung (right) stand in front of the Albany Senior Center with Ruth Clapton after receiving recognition for their library volunteer work. For many years, Bill Hartung drove a blue truck, hauling used books to the Friends of the Albany Library book sales. Today a bookcase shaped like the truck appears in the children's area of the library, commemorating these efforts. (Courtesy Mary Hartung, AHS.)

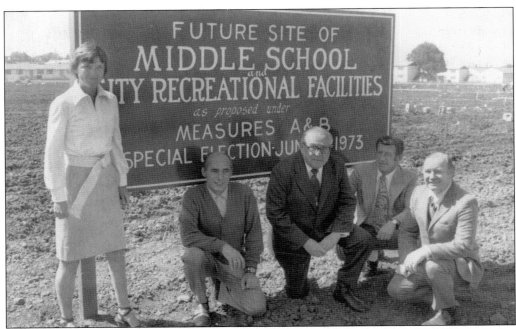

The mid-1970s was a time of great upheaval in the Albany school system. In 1971, just a few months after the state declared Marin School and portions of Cornell School earthquake hazards, both were closed. Numerous committees, with broad community involvement, studied how to upgrade and reorganize the schools. In 1973, a successful $1.62-million bond measure and a state loan enabled the rebuilding of Marin and portions of Cornell, as well as the construction of a new middle school at Jackson and Buchanan Streets. Above, school board members and city officials pose at the Gill Tract site of the future middle school. Pictured from left to right are Ruth Ganong (later Albany's third woman mayor), Joe Carlevaro, Lewis Howell, Jack Rosano, and Red Call. Albany Middle School, which opened in 1976, is seen below. (Above courtesy Ruth Ganong, AHS; below courtesy Albany Middle School, AHS.)

Albany High School's marching band is seen on Key Route Boulevard, in front of the old high school, in 1970. During the mid-1970s, when Marin and Cornell Schools were closed for rebuilding, students crowded into the high school, where a renovated basement was converted into classrooms. In addition, double sessions ran from 7:00 a.m. to 12:00 p.m. and 12:30 p.m. to 5:00 p.m. to accommodate all the students. (Courtesy Eugene Hellwig, AHS.)

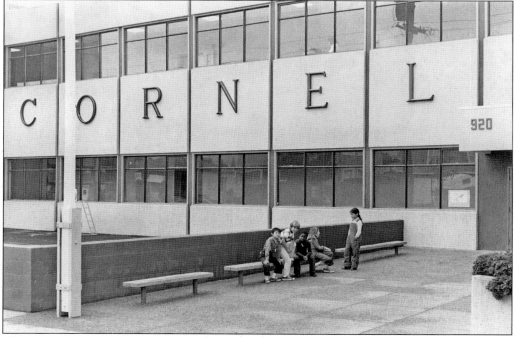

The portion of Cornell School facing Talbot Avenue was remodeled in the mid-1970s. (Courtesy Albany Unified School District, ALHC.)

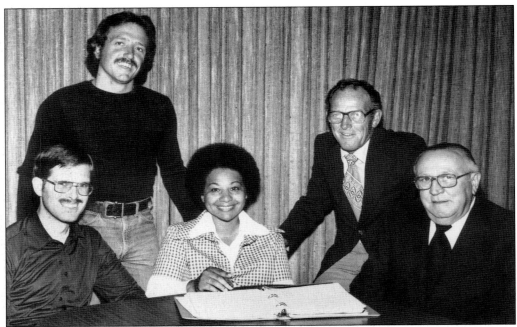

In 1976, Joyce Jackson became Albany's first African American mayor and the second woman to hold the position. Members of the city council at the time were, from left to right, Patrick Griffin, Michael Gleason, Joyce Jackson, Bob Luoma, and Lewis Howell. Jackson, Griffin, and Gleason were part of a 1977 recall election in which Griffin and Gleason (mayor from 1974 to 1975) lost their seats on the council and Jackson was retained. Jackson went on to serve until 1980. (Courtesy Fern Luoma, AHS.)

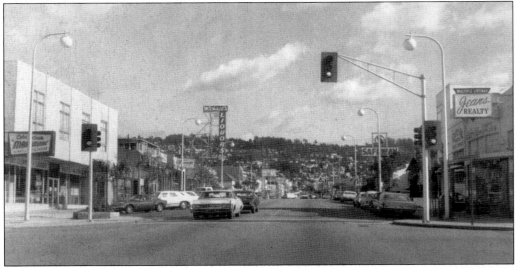

This c. 1970 view of the Solano and Santa Fe Avenue intersection, looking east, includes Jeans Realty and Michael's Liquors, two longtime businesses. Jeans Realty, still in the same location, moved from Masonic and Solano Avenues in 1965 when the BART tracks were installed. The Fahmie family ran Michael's Liquors for many years. Out of view near Michael's is another long-term business, Walker's Pie Shop, which opened in 1964. (Courtesy ALHC.)

City officials watch as new lighting is installed in front of the Ellis-Olson Mortuary, at 727 San Pablo Avenue, around 1970. Shown here from left to right are Dick Clark; Harold and May Ellis-Olson, owners of the mortuary; Red Call; and Yvonne Walkup. At the time, the mortuary had been in business here for nearly 40 years. It closed its doors in Albany in 2001. (Courtesy May Ellis-Olson, AHS.)

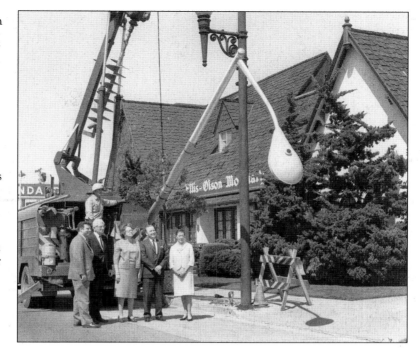

The third graders of Mrs. Teague's class at Vista School are lined up and ready on portrait day in 1979. (Courtesy Albany Unified School District, ALHC.)

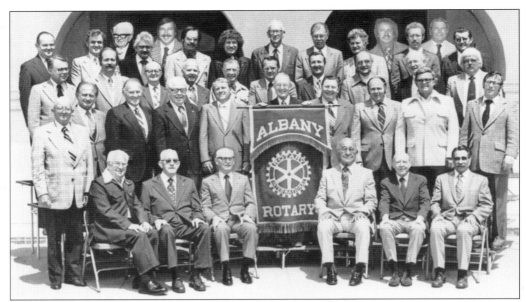

In 1979, the Albany Rotary Club celebrated its 50th anniversary at the Veterans' Memorial Building, which has been a part of Memorial Park since 1932. Included in this photograph are many longtime Rotarians, as well as a few "pasted in" members who were not present. Joe Villa, an Albany pioneer and business owner, appears in the first row, third from the right. The club established the Villa Memorial Fund, an annual college scholarship program for youth, in his honor. (Courtesy Fern Luoma, ALHC.)

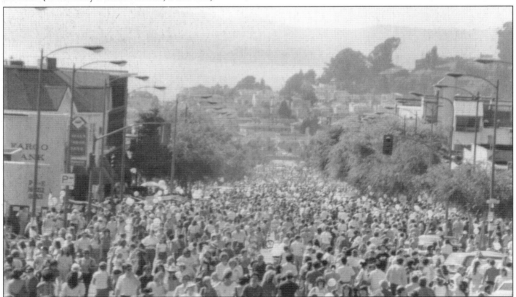

The Solano Stroll, a popular annual street fair along Solano Avenue, began in September 1976. At first, the Stroll took place on a weekday evening but then changed to a daylong Sunday event a few years later. In this westward view, crowds fill nearly the entire length of the street to San Pablo Avenue. Today the event attracts an estimated 200,000 people. (Courtesy Roland de La Torre, AHS.)

Nine

TOWARD THE FUTURE

This last chapter focuses on two aspects of Albany that bring us forward to contemporary times: modern structures added to the city in recent years and views of Albany that bring us full circle, providing perspective on the change that has occurred during the over-100 years of city history. Above, the new Albany Library and Community Center is pictured shortly after its completion in 1994. Construction of the center began in 1992, after the city purchased the old Albany–Alta Bates Hospital on Marin Avenue between Masonic Avenue and Evelyn Street. (Courtesy Richard Russo, ALHC.)

In 1998, the old Albany High School and Gymnasium were torn down to make way for a more earthquake-safe structure. The new Albany High School, shown here, opened in 2001. (Courtesy Karen Sorensen, AHS.)

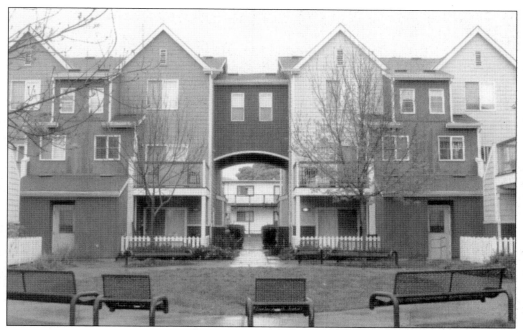

World War II–era housing, originally built for shipyard workers and other wartime personnel, was razed to allow for the construction of these University Village townhouses. The new units opened in 2000. (Courtesy Karen Sorensen, AHS.)

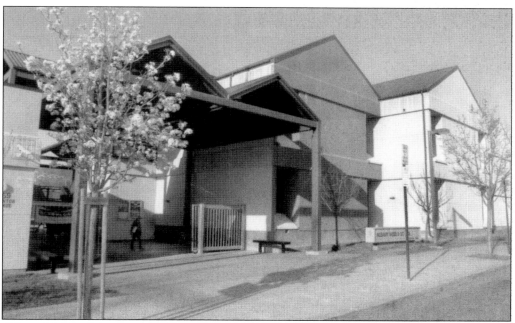

Albany Middle School moved from its previous location at 1000 Jackson Street to a new facility at 1259 Brighton Street in 1999. The new school, pictured, was built on the former site of the Hill Lumber Company, which operated in this location for decades. The former middle school is now Ocean View Elementary School. (Courtesy Karen Sorensen, AHS.)

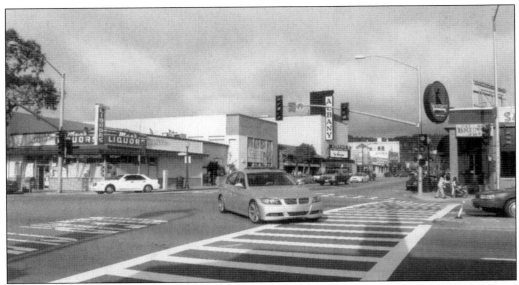

Today the San Pablo and Solano Avenue intersection continues to be a central hub of business and transportation in Albany (compare to pages 28 and 37). (Courtesy Karen Sorensen, AHS.)

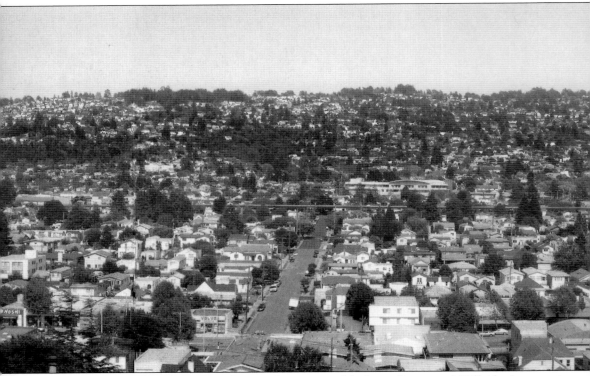

This photograph, taken in 2007 near the corner of Jackson Street and Hillside Avenue, is dramatically different from a similar view captured in 1911 (see pages 18–19). While Albany has changed considerably over the last 100 years—from country living among fields and wildflowers

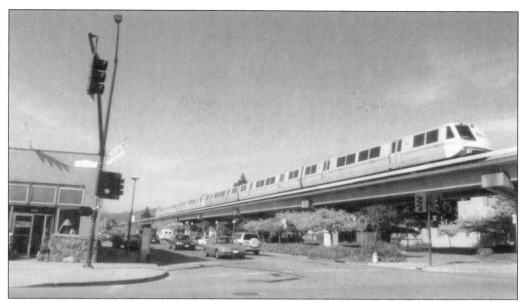

This 2007 view of Masonic and Solano Avenues contrasts sharply with a 1913 picture of the same location (compare to page 25). (Courtesy Karen Sorensen, AHS.)

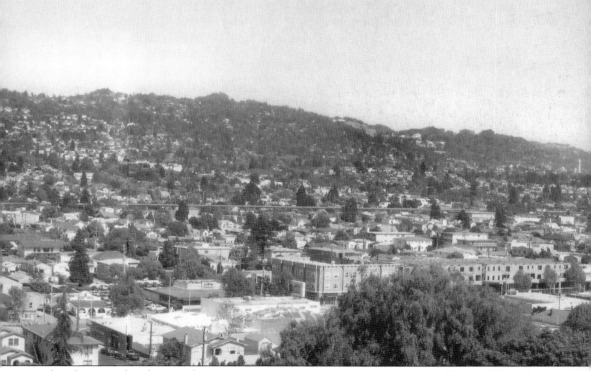

to urban living with culture and convenience—it remains, in many ways, a small town. The rich history of this 1.5-square-mile area provides valuable perspective for the journey ahead. (Courtesy Karen Sorensen, AHS.)

Across America, People are Discovering Something Wonderful. Their Heritage.

Arcadia Publishing is the leading local history publisher in the United States. With more than 3,000 titles in print and hundreds of new titles released every year, Arcadia has extensive specialized experience chronicling the history of communities and celebrating America's hidden stories, bringing to life the people, places, and events from the past. To discover the history of other communities across the nation, please visit:

www.arcadiapublishing.com

Customized search tools allow you to find regional history books about the town where you grew up, the cities where your friends and family live, the town where your parents met, or even that retirement spot you've been dreaming about.